SLOTHLOVE

Published by Inkshares, Inc., San Francisco, California
www.inkshares.com

Edited and designed by Girl Friday Productions
www.girlfridayproductions.com

Cover design by Todd Bates
Photography by Sam Trull

ISBN: 9781941758496
e-ISBN: 9781941758502
Library of Congress Control Number: 2015939064

First edition

Printed in the United States of America

SLOTHLOVE

An inspiring and intimate visual journey into the world of sloths

BY SAM TRULL

INKSHARES

For all of the sloths who have touched my heart but especially Newbie, who not only defined "Slothlove" but forever changed my definition of love.

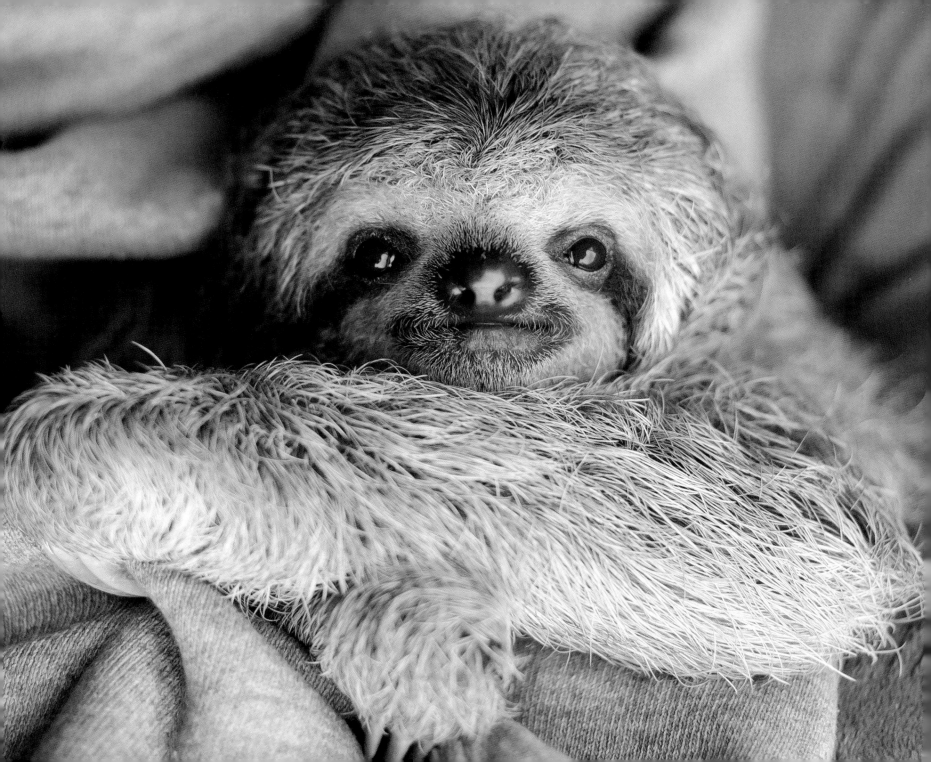

Contents

Introduction

My life revolves around sloths.

When I wake up in the morning, I think about sloths; when I go to sleep at night, I think about sloths; and throughout the day, when not directly working on another project, I am completely engrossed in thoughts about sloths. Just this morning I shot out of bed with another research idea about sloths and went directly to my computer to start typing. If I could remember my dreams better, I'm pretty sure I would find that I dream about sloths, too.

This is not an exaggeration. I'm sure that upon hearing how I spend all of my time, some people dismiss me instantly as a sloth version of a "crazy cat lady," and that's not an entirely inaccurate description. Others may wonder why on earth a thirty-four-year-old single woman would be so utterly consumed with thoughts about sloths. Why live out in the middle of the Costa Rican jungle with no air-conditioning, no bathroom, no closet, and only a couple of flip-flops and some boots for shoes? Why wake up in the middle of the night every night for the past two and a half years to feed baby sloths? Why say good-bye to made-to-order Starbucks mochas and the Whole Foods salad bar? Why live thousands of miles from your friends and family and any chance of a normal, comfortable life?

The answer is simple: sloths saved my life.

No, I'm not talking about mouth-to-mouth resuscitation or pulled-me-out-of-a-burning-building type of lifesaving. I'm talking more the Elizabeth Gilbert *Eat, Pray, Love* type of lifesaving.

A little more than eight years ago my life—and the life I thought I was headed toward—was irreversibly, drastically, and suddenly changed.

On the morning of May 19, 2007, I woke up alone. I remember becoming instantly angry, thinking my fiancé, Jabari, had stayed out all night and fallen asleep on a friend's couch again. His phone went straight to voice mail. I was so pissed off that he hadn't taken just a couple of minutes to give me a heads-up as to his whereabouts before his phone ran out of juice.

Still annoyed with him, I complained to my coworkers about it most of the morning until I received a phone call from a state trooper. Jabari had been in a car accident; he'd been speeding and lost control of his car.

"Is he OK?" I frantically asked.

"Yes, we just need you to come back to your apartment so we can talk about his car."

As I walked up to the patrol car outside my apartment, I could see through the driver's side window that the police officer was holding Jabari's driver's license—and that's when I knew. He was gone. I was never going to hear his voice again, smell his shirts again, laugh with him or hold him again.

The emptiness was vast. At only twenty-six years old, my life felt over. And the life I had known for the past ten years *was* over. He had been my home, and now I had to find a new center of gravity.

Only six months later, my father passed away following a four-year battle with bone marrow cancer. Needless to say, 2007 was a rough year. In the grand scheme of the world there have been and there will be much bigger tragedies. But for me—in my own little slice of the world—2007 was devastating. Two of the most important people to me, two people who I loved immensely, two people who made me feel safe and special, were permanently gone.

In the first few years after these tragedies, I struggled to make sense of it all. I tried buying a house, moved to West Africa for a bit, traveled, and even switched careers a few times. I kept hoping that something would click and life would seem OK again. I had always been a very passionate person who went after what I wanted, but during that time I had no idea what I wanted—because what I wanted was impossible. I wanted my loved ones to not be dead.

Three years ago, attempting another fresh start, I landed on Costa Rican soil to work in a wildlife rehabilitation clinic run by an organization called Kids Saving the Rainforest (KSTR). I needed to contribute to making the world a better place in a way that resonated with my soul. For me, what better way to do that than by helping orphaned and injured animals to heal and eventually be released back into the wild?

In Costa Rica, human encroachment and degradation to the rainforest cause a wide variety of wildlife species to pass through our clinic doors. The reasons vary—from electrocutions to dog attacks to illegal pet trade confiscations—but the result is the same: these animals would die without us.

Having worked with and studied primates for over fifteen years, I thought Costa Rica seemed like a great fit for a primatologist who wanted to contribute to primate conservation on the front lines. What I didn't realize was that while I would come to Costa Rica for the monkeys, I would stay for the sloths.

The first time I held a baby sloth I was learning how to feed her. Her tiny claws clutched tightly to my shirt, and her nose wiggled with innocent perfection. Her breathing was delicate and adorable.

I was told baby sloths don't usually survive well in captivity, and there was a good chance she wouldn't make it. Looking down at her sleeping face, I made her a promise that I would do everything in my power to give her the life she deserved. I would always put her needs first, and I would make sure she felt safe, comfortable—and loved. That was two and

a half years ago. Not only did that sloth survive, but there are now eleven orphaned sloths that I care for around the clock.

There's nothing I enjoy more than being with sloths. Making them happy makes me happy. I love the way they yawn, the way they scratch their faces, and the way they look at me when they want me to pick them up. The orphaned sloths have healed my heart in a way no human ever could—all while I try so desperately to heal them and get them back into the Costa Rican jungle. Having lost their mothers to dogs, electric wires, cars, or general forest destruction, they come in scared and alone and in need of a new place to call home. Like me, they are in need of a new center of gravity.

In the photos in this book, the sloths aren't just looking at a camera lens; they are looking at what they perceive as their mom. These photos provide an opportunity to see the sloths the way I see them—and the way they see me.

I hope that in viewing these adorable photos while learning more about sloths, readers will appreciate how special they are, understand and rethink the misconceptions about sloths, and feel inspired to help. Loving sloths saved my life, and now I hope that by sharing their photos, stories, and facts, I can spread the Slothlove—and save more sloth lives.

Thank you,
Sam
#Slothlove

Definition of Slothlove:

The complete adoration of sloths and the infectious desire to improve their well-being and assure their conservation.

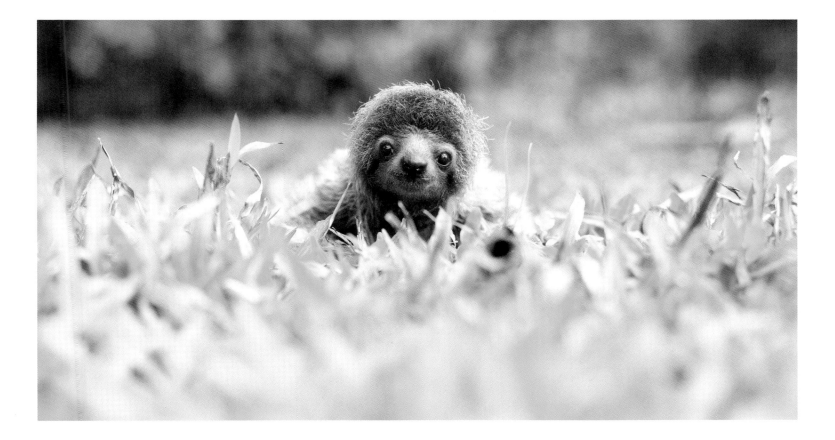

Sloth Facts

These facts are based on knowledge I gained through my formal education and experience working with sloths. I've noted where I've drawn the information from a particular source, which has a corresponding entry in the reference list.

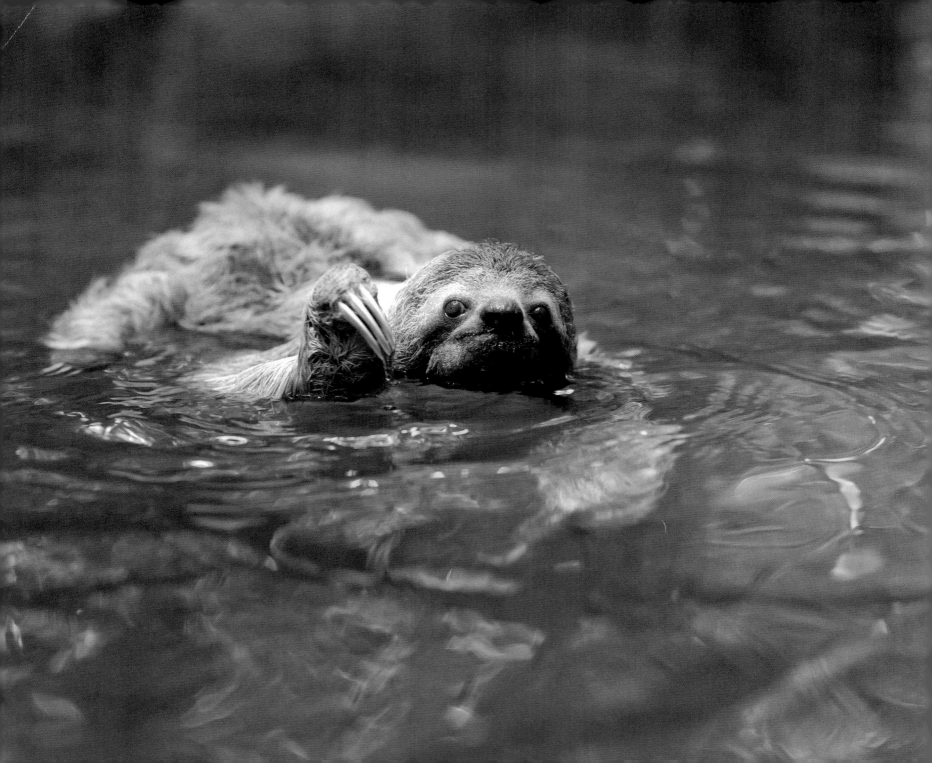

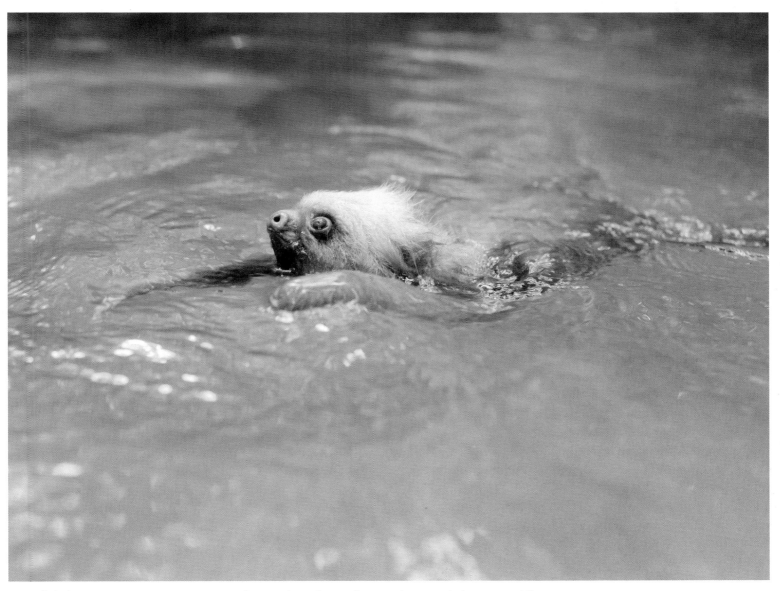

1. All sloth species are great swimmers. Their stroke is basically a sophisticated doggie paddle.

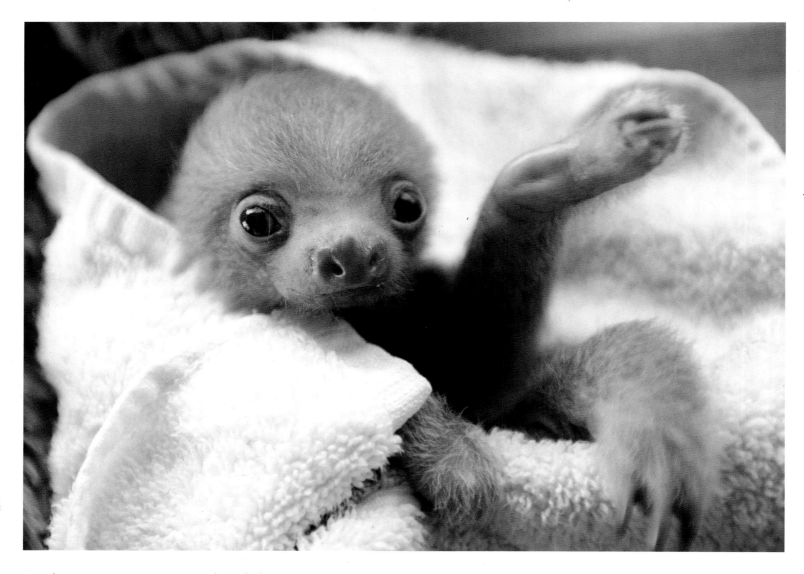

2. The common names, "two-toed" and "three-toed," are actually misnomers. All sloths have three toes. The difference is really in the number of fingers on their hands: some sloths have two fingers while others have three! They really should be described as "two-fingered" and "three-fingered."

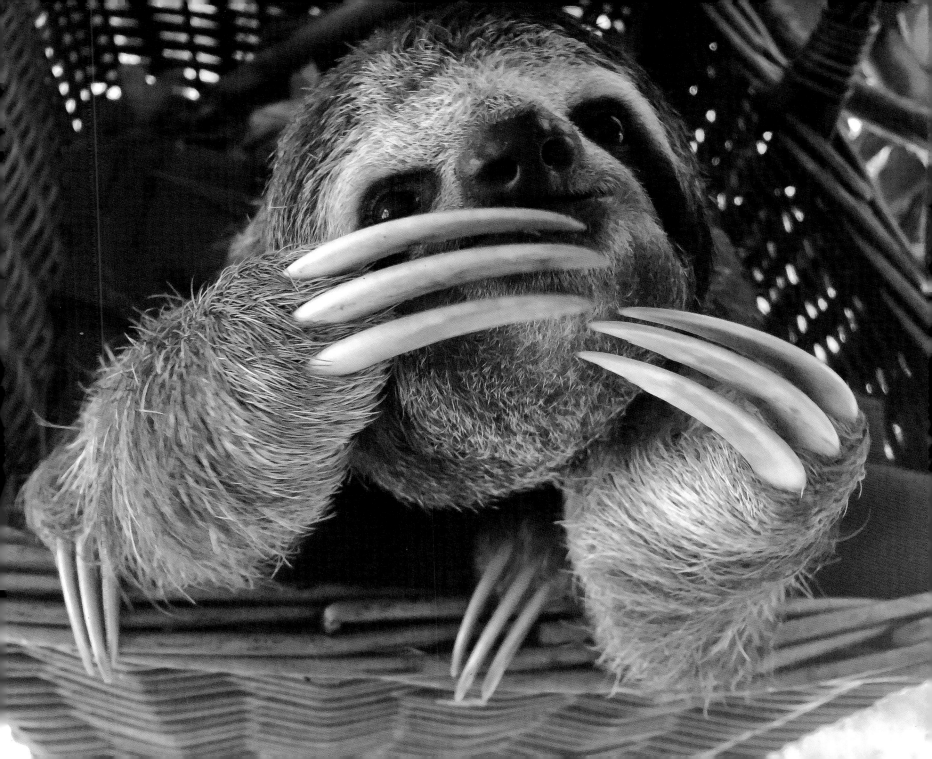

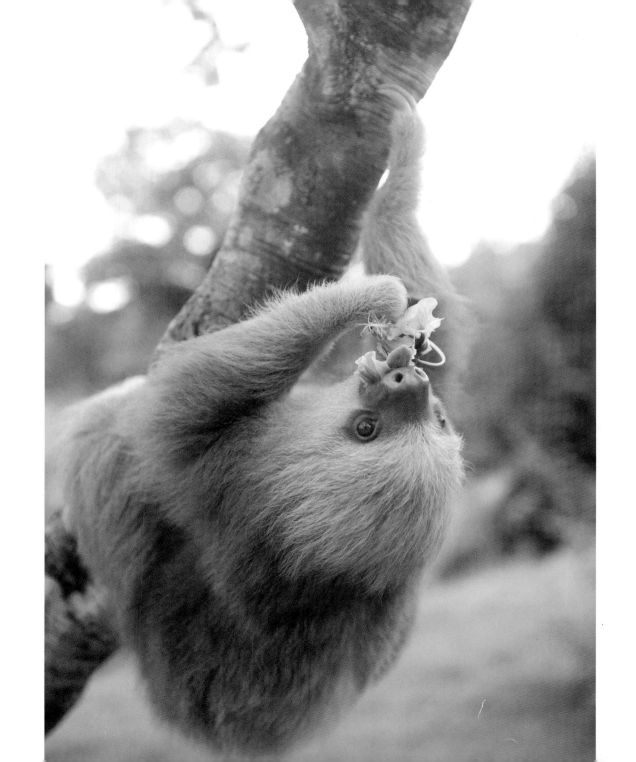

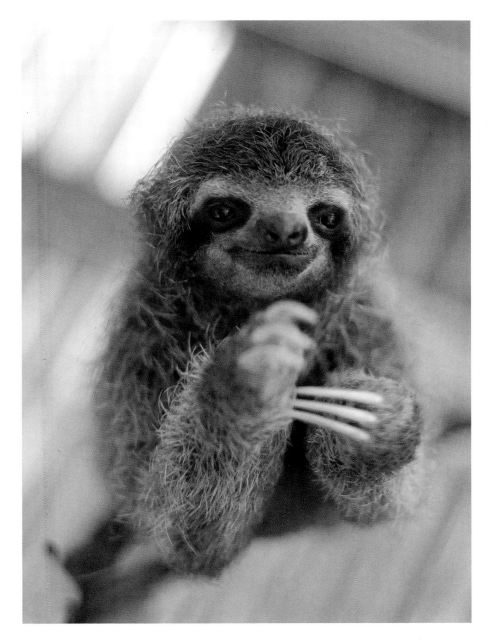

3. Sloths use their arms much like humans do: they grab food, scratch their faces, and hug their friends. This further justifies the use of the terms "two-fingered" and "three-fingered" rather than "two-toed" and "three-toed."

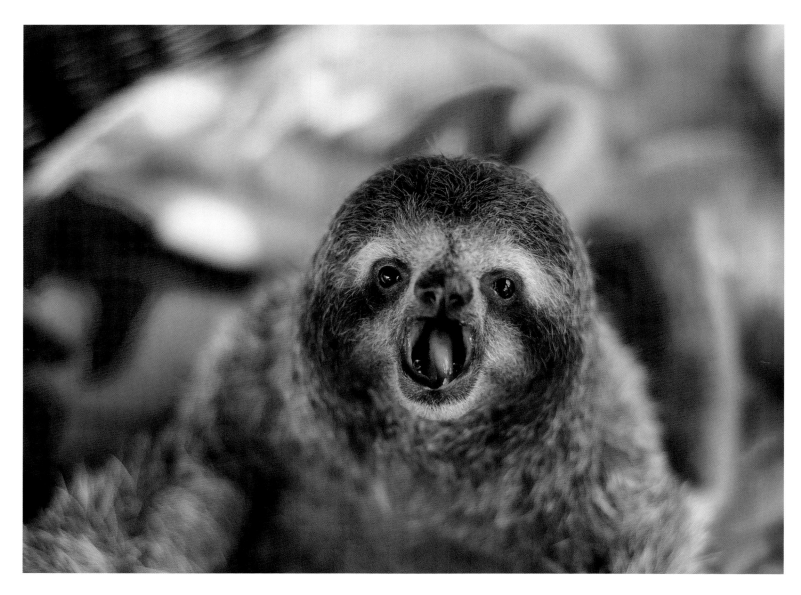

4. Sloths have teeth unlike any other mammal. They have no incisors, and their continuously growing molars have no enamel. (Vizcaíno 2009)

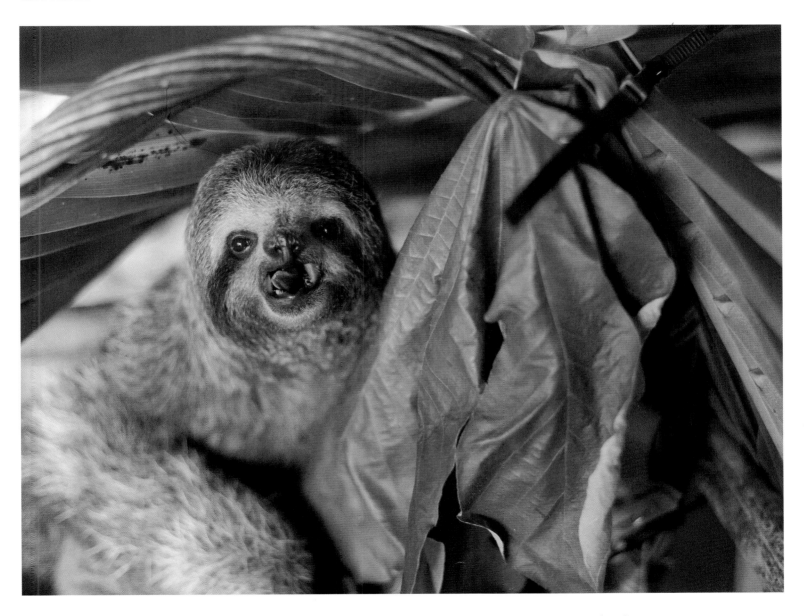

5 Because they have no enamel, sloth teeth become very dark brown or even black due to the leaves that they eat.

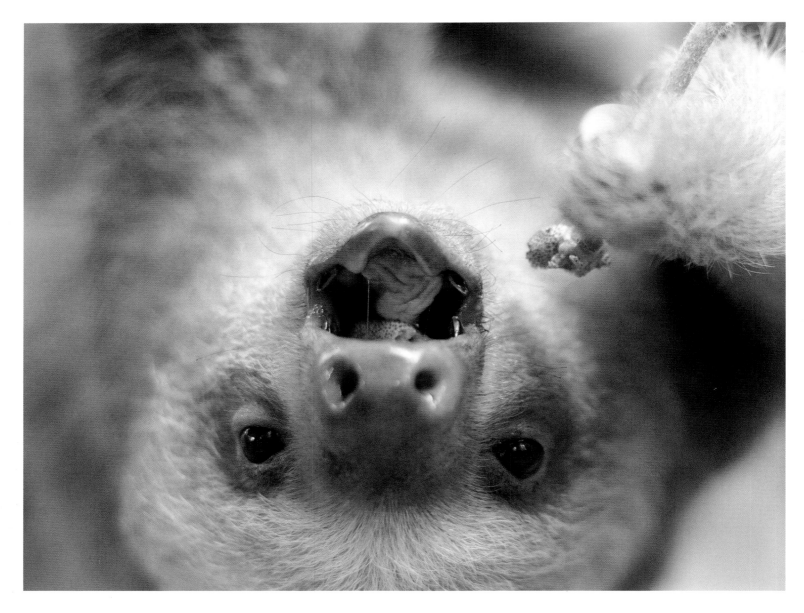

6. Two-fingered sloths have large canine-like premolars and strong jaws, making their bite very dangerous and painful!

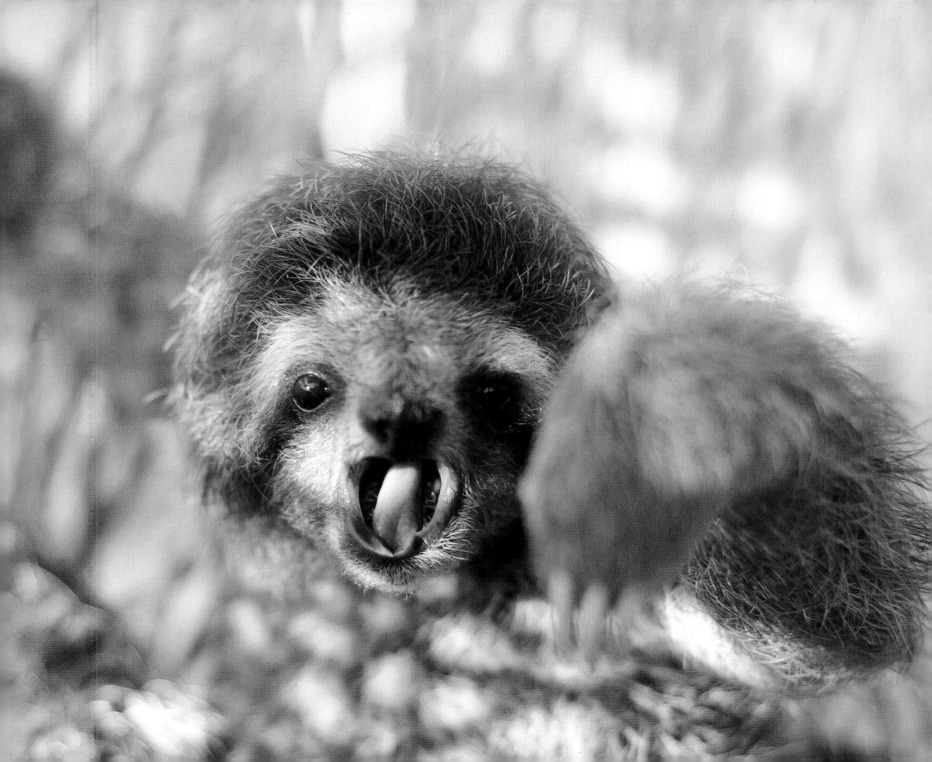

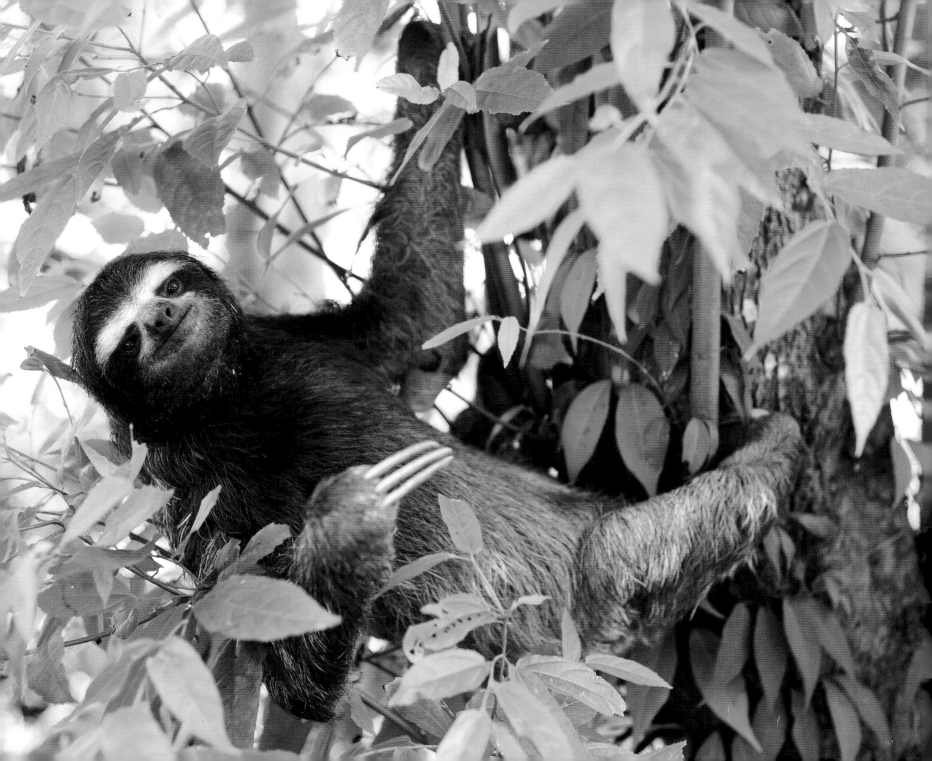

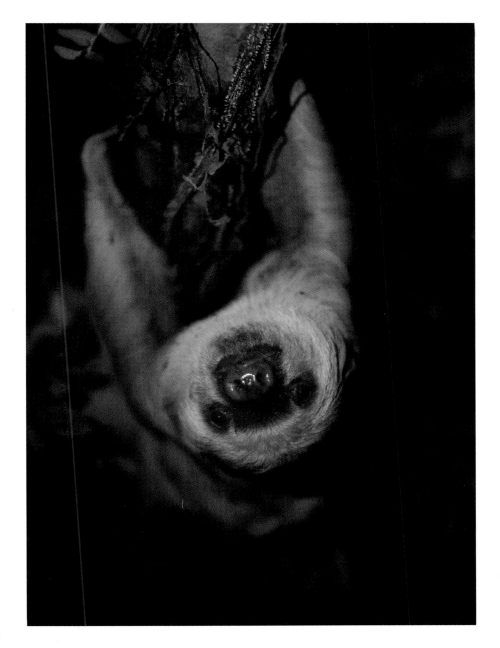

7. Two-fingered sloths are nocturnal, and three-fingered sloths are mostly diurnal but can also be active at night.

A C-Section Story

In October 2014, we received an adult female three-fingered sloth at the Kids Saving the Rainforest (KSTR) wildlife rescue clinic. Having fallen from a tree, she had experienced some head trauma and was having a seizure. When she was brought in, I swear we made eye contact. Instantly, I was hooked.

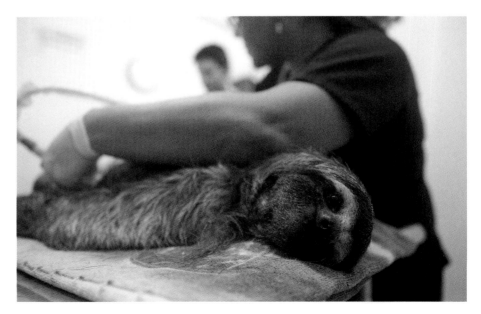

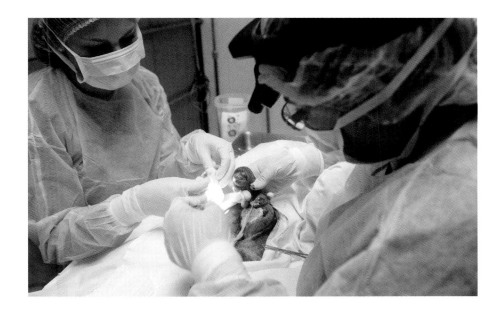

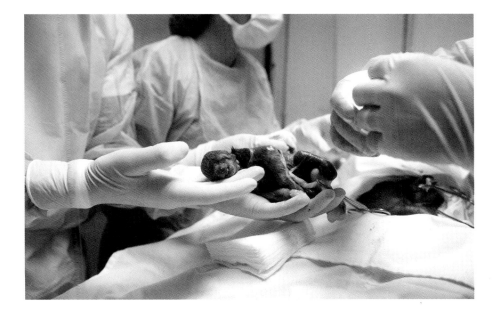

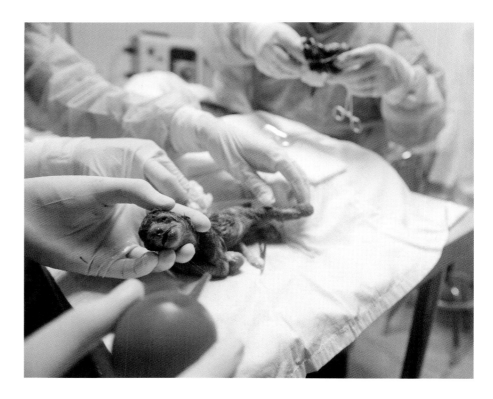

This was the first sloth seizure I had seen, and true to sloth nature, it was a slow seizure. In fact, it was more like a neurotic tic than a typical seizure seen in human and nonhuman primates. Upon examination I determined that she had not fractured her skull (yay!) and that she was pregnant (not so yay). After speaking with our vet, I started her with medications and supportive care. Then it became a waiting game.

A few days later she wasn't looking much better. Her eyes were bright and her lungs sounded good, but she just wasn't moving much and still had some rigidity to her limbs. Her prognosis was poor, and euthanasia was even discussed. However, I wanted to keep fighting for this mom and her unborn baby, and my gut told me not to give up.

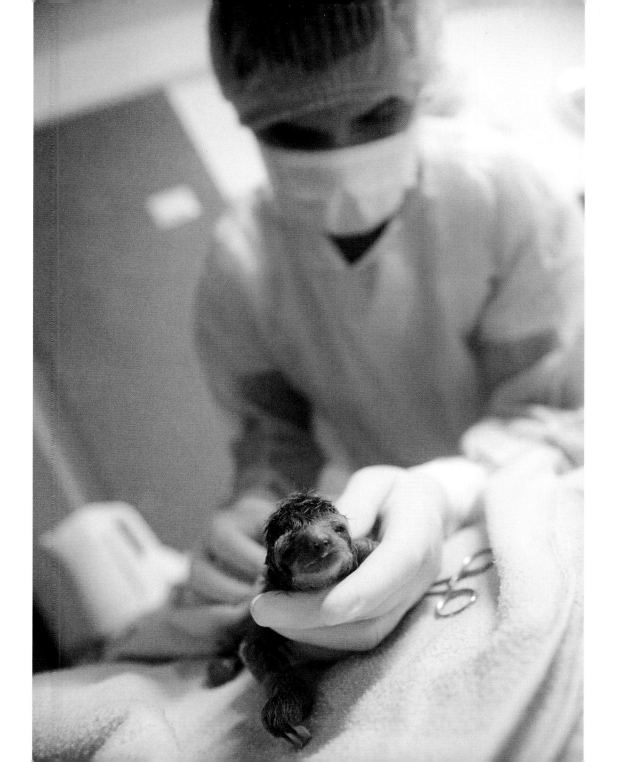

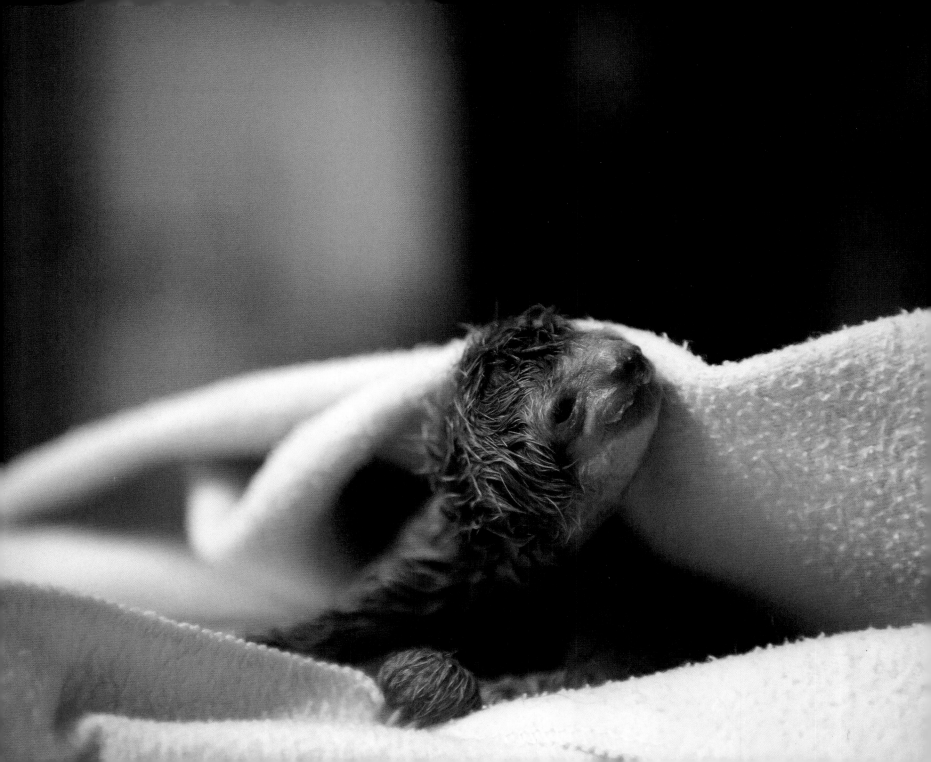

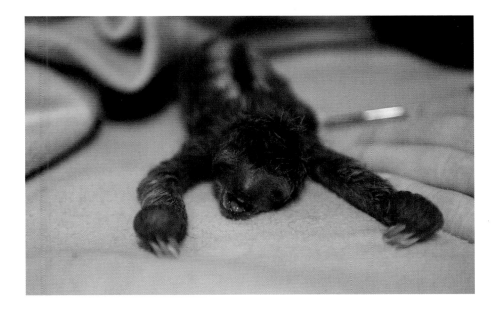

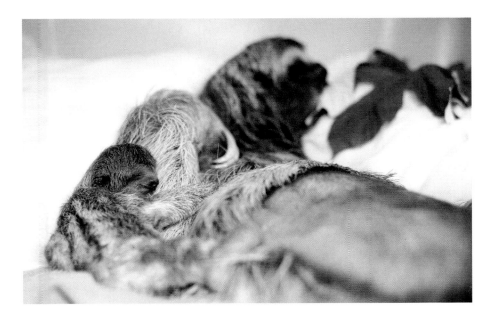

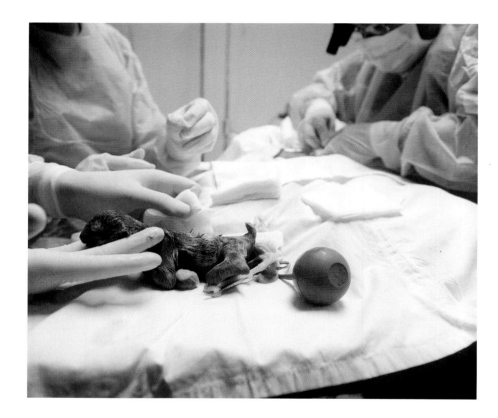

Two days later, the mom started to show signs of labor. I'd never seen a sloth have contractions, but those painful moments when her entire body seemed to be cramping and her arms reached out for anything to squeeze seemed like contractions to me. So I started documenting when they started and when they ended. I couldn't help but wonder if she could successfully have the baby with her injuries. Was a difficult pregnancy why she fell in the first place?

The contractions were all over the place. There was no real pattern. After I spent twenty-four hours documenting these contractions, she had an hour-long contraction that was so intense that multiple times I thought

at any moment her vagina would start to open and a head would crown. However, the contraction ended and still no baby. It became obvious to me that more diagnostics were needed in order to determine how best we could help this mom.

We arrived at the office of veterinarian Yesse Alpizar in Herradura. I'd taken other patients to Yesse before and knew she was one of the kindest and smartest vets I'd ever met. She also happened to have a clinic equipped with a digital X-ray and ultrasound machine.

After getting a complete history on the mama sloth, Yesse examined her and agreed with me that she was in labor.

She took an X-ray, and while it was amazing to see the little life inside the mom's belly, unfortunately the baby was in a breech position and the mom was completely full of urine and feces (sloths can hold up to 30 percent of their body weight in urine/feces), meaning that it was unlikely the baby would change position. At this point, a C-section was discussed, but we needed to check the baby with an ultrasound to confirm a heartbeat and the exact position.

With the first swipe of the ultrasound probe, we didn't see a heartbeat. My heart sank. Just one day before I had felt the baby move inside of the mom's belly, so I knew that recently it was alive, and I could only hope that it still was.

Yesse kept swiping the probe around the mom's belly, searching and searching for a tiny flicker of the heart. Was the baby still alive? It was. Luckily, I had brought my camera and was able to capture the entire procedure and the first time a sloth was born via C-section.

Unfortunately, this story did not have a happy ending. Both mama and baby died within a few weeks of the procedure. Even though the ultimate outcome was sad, I still feel that this is an important story to tell. A life was created, and a mom and baby had a short time together. It was time they never would have been granted had we just given up. Every life is meaningful and also a learning experience that helps save future lives.

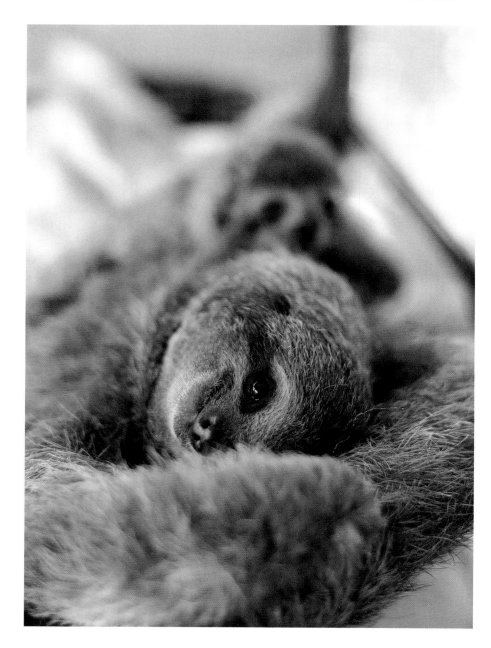

8. Activity level in three-fingered sloths is often dependent on ambient temperature. They are a little like Goldilocks; they don't like it too hot or too cold.

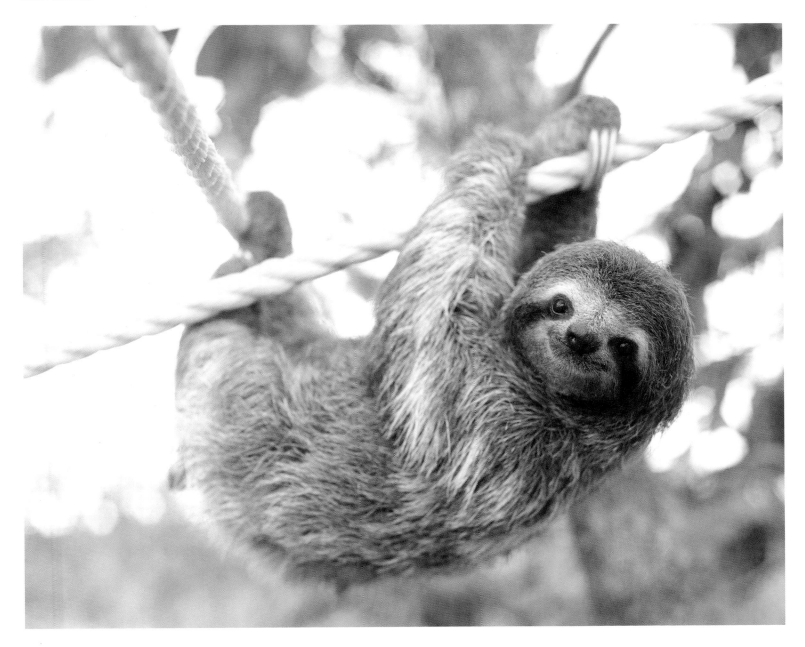

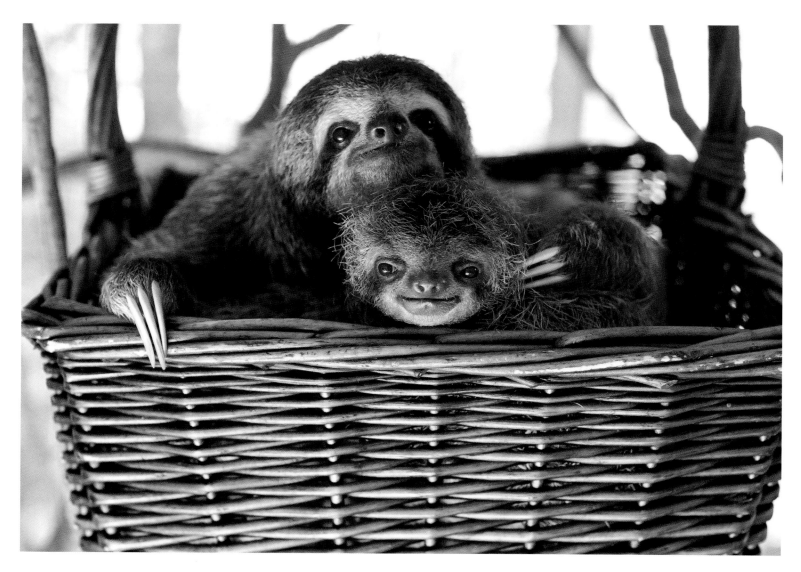

9. Sloths are heterothermic, meaning they have varied body temperatures. Their body temperature can range from 86 to 98.6 degrees Fahrenheit (30 to 37 degrees Celsius) and still be alive. (Britton and Atkinson 1938) However, the average temperature I have seen in healthy individuals ranges between 91.4 and 95 degrees Fahrenheit (33 and 35 degrees Celsius).

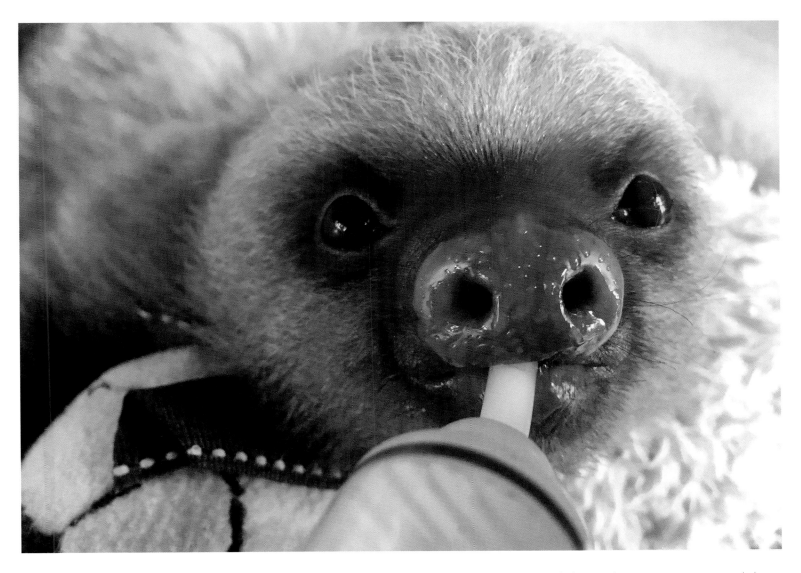

10. Because they do not sweat (two-fingered sloths sweat tiny amounts from their nose) or shiver, sloths use their environment to cool down and warm up. However, they do perform quick and shallow breaths through their noses when they are hot, which may serve a similar purpose as panting in dogs.

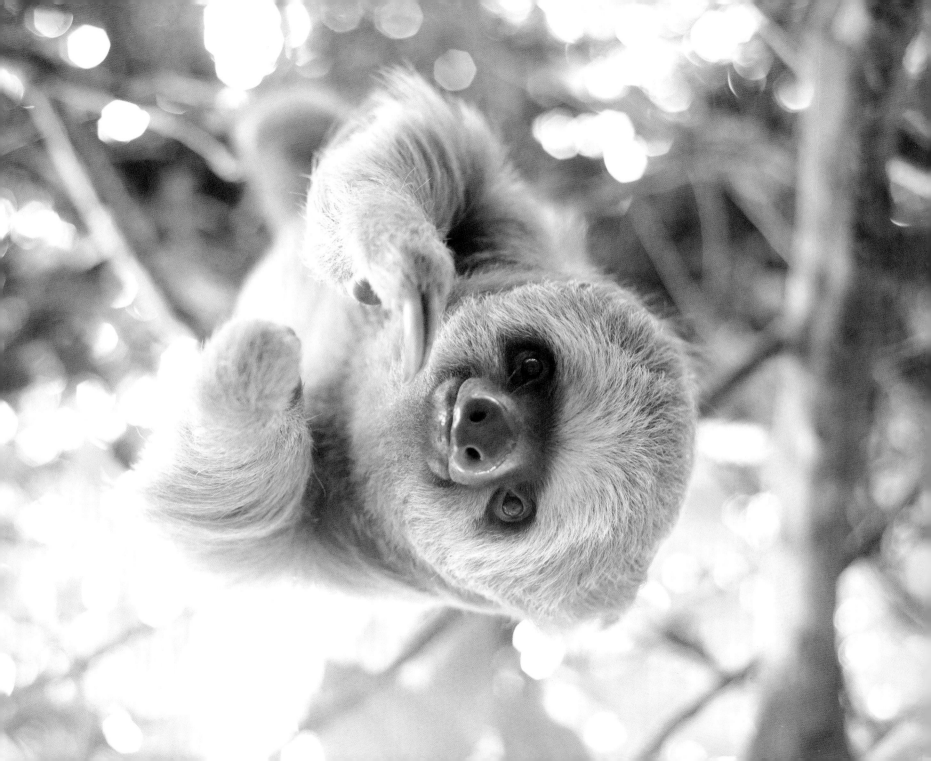

11. Sloths have the least muscle mass of any mammal, but don't let that fool you. They have abs of steel.

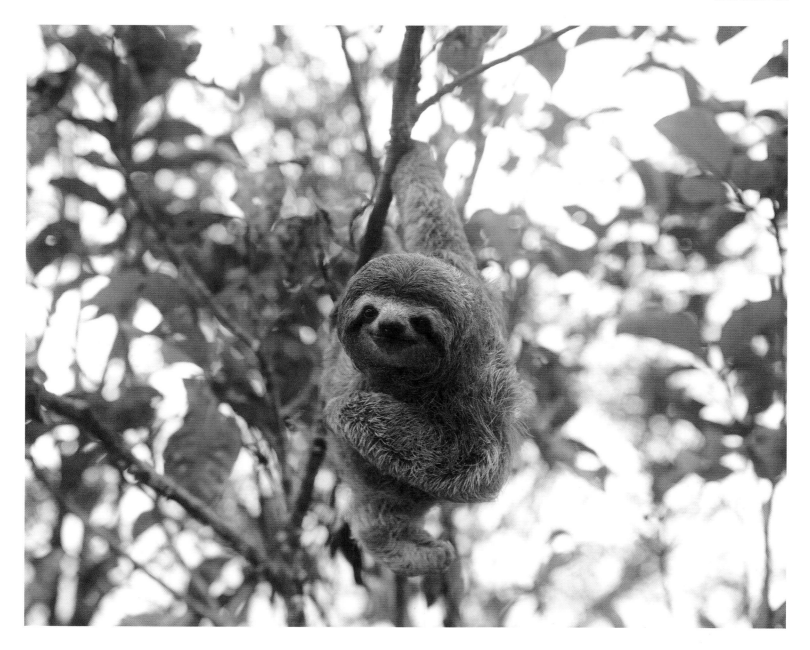

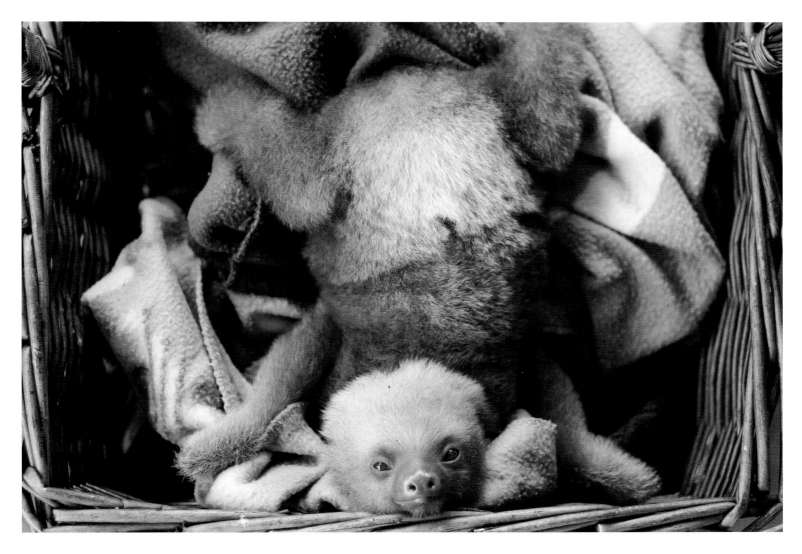

12. All mammals have seven cervical vertebrae (even giraffes!) except manatees, who have six, and sloths, who can have between five and ten. Think about that for a minute: sloths can have more bones in their neck than a giraffe! To make things even more unique, two-fingered sloths have between five and seven and three-fingered sloths have between eight and ten. The number of vertebrae varies by individual. (Buchholtz and Stepien 2009)

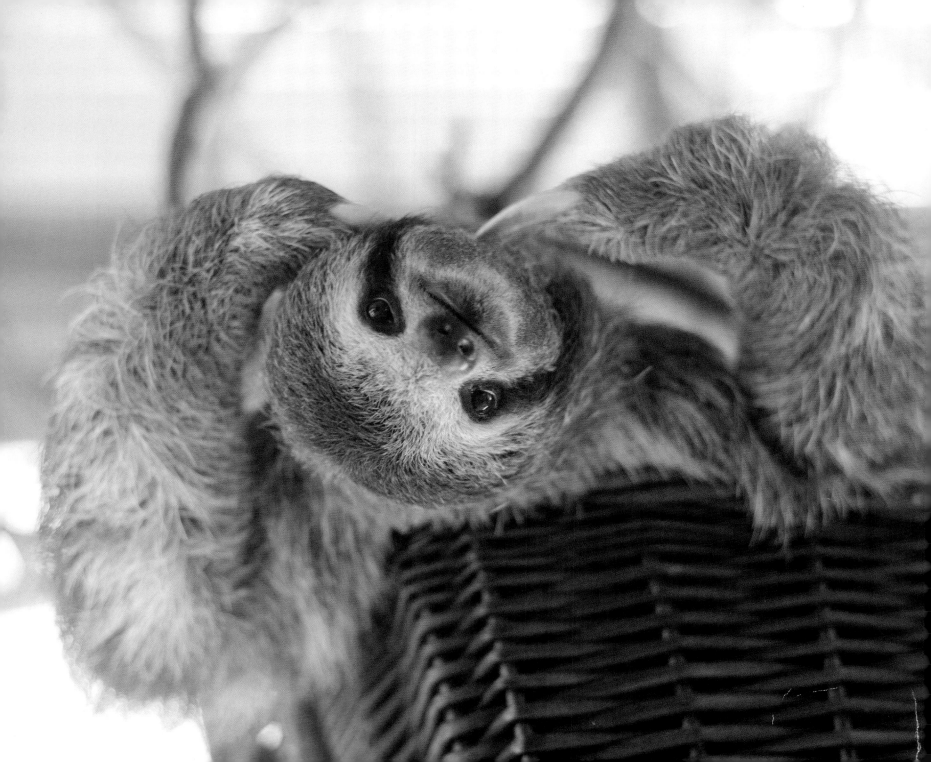

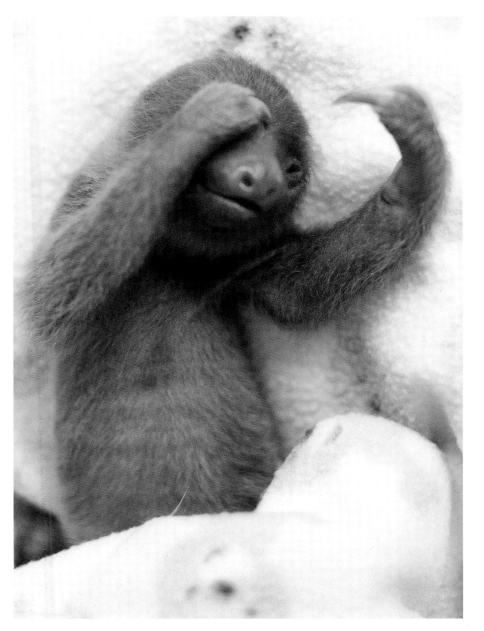

13. The inner ear of a sloth varies in shape between individuals, rendering it less functional. This means they have terrible balance, so it's lucky they move slowly and don't make quick decisions. (Billet et al. 2012)

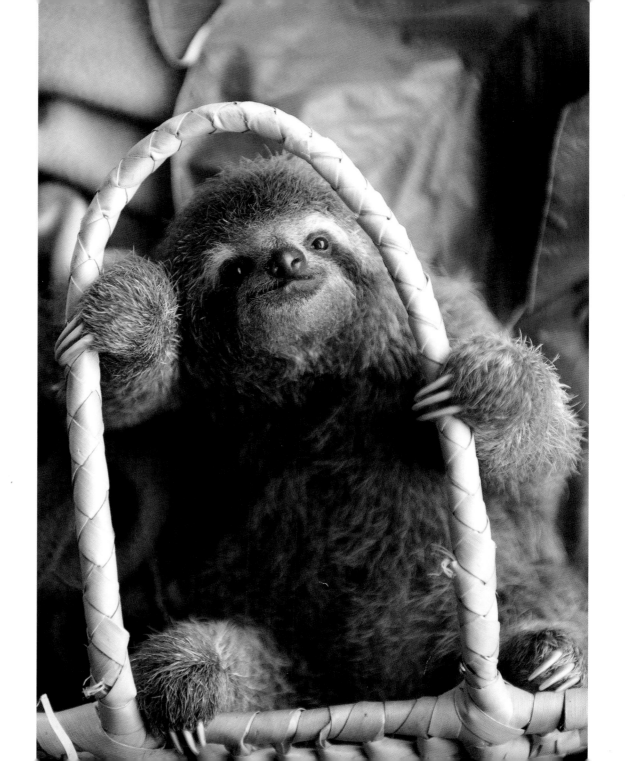

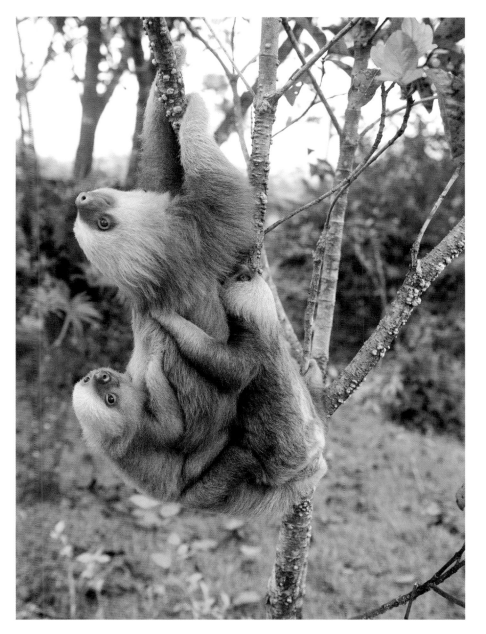

14. Two-fingered sloths (average adult size 13 pounds / 6 kilograms) are much bigger than three-fingered sloths (average adult size 9 pounds / 4 kilograms).

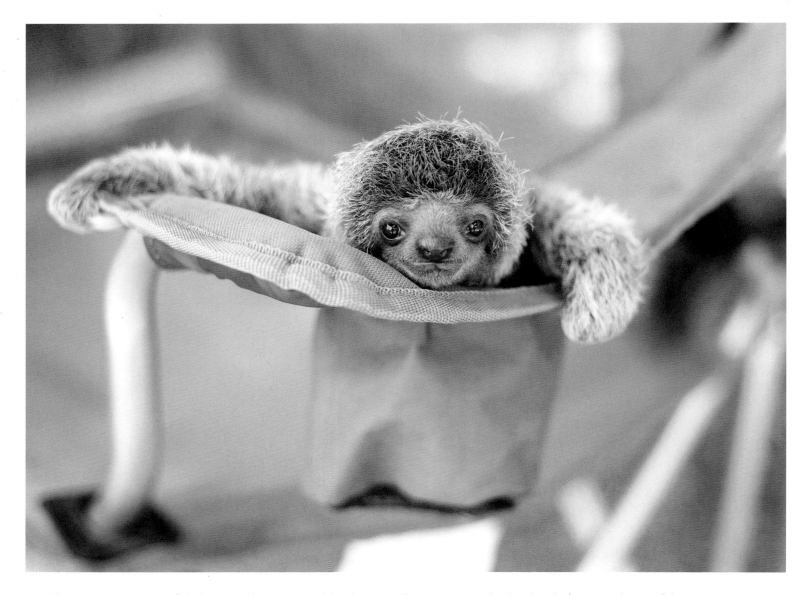

15. There are six species of sloths currently recognized by the scientific community. This book only features photos of the two species found in Costa Rica: Hoffman's two-toed sloth (*Choloepus hoffmanni*) and the brown-throated three-toed sloth (*Bradypus variegatus*).

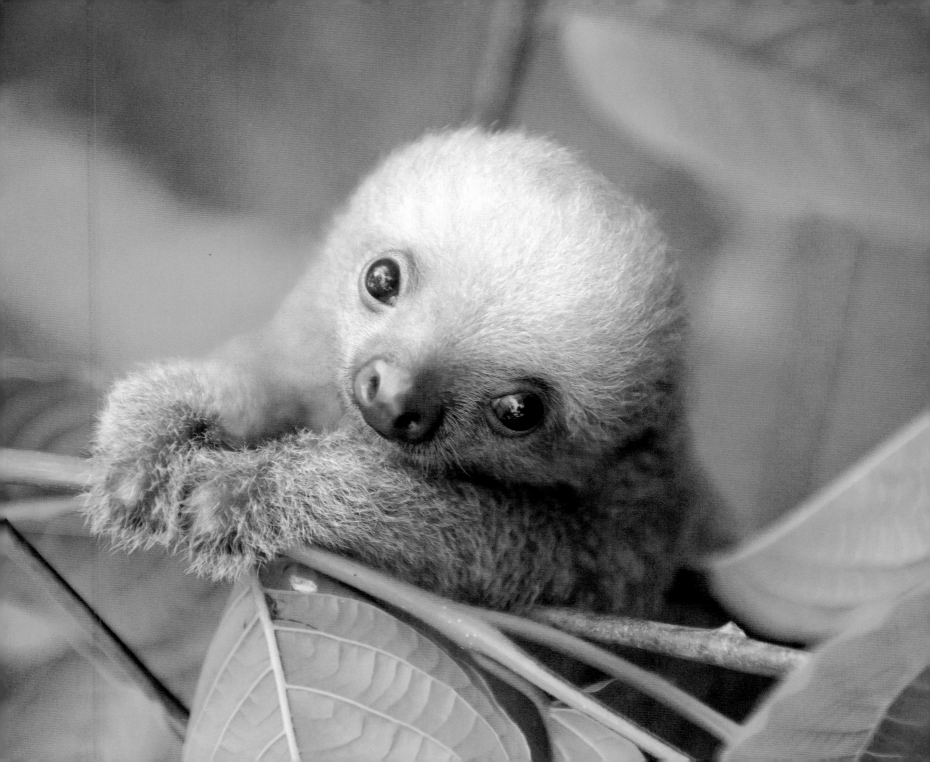

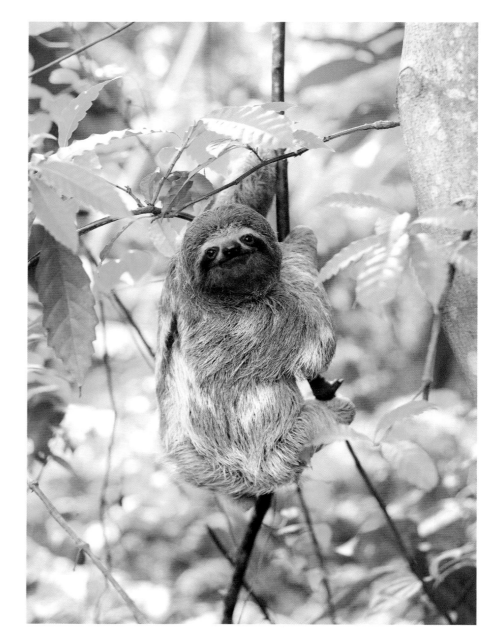

16. The two Costa Rican sloth genera stop sharing genetics at the suborder level and are believed to have genetically split off forty million years ago. Because they have different ancestors (two-fingered evolved from the giant ground sloths, and three-fingered evolved from another arboreal ancestor), they are a great example of convergent evolution, which is when different species independently evolve similar traits based on the same environmental pressures. In fact, the similarities between the two genera of sloths make them one of the most extreme examples of convergent evolution in mammals. (Gaudin 2004)

Chuck

If there has ever existed a creature cuter than Chuck, I'd like to see it. Chuck is really *that* cute. If his soulful eyes aren't enough to turn everyone into Chuck-addicts, his puffy hair and perfect demeanor sure will.

Chuck first arrived at the KSTR rescue center when he was only a couple of weeks old. Good Samaritans found him in a tree, where he'd been crying for his mother for over two days. Most likely his mother had died. There are a lot of dangers for sloth moms in areas where humans live—cars, dogs, electric wires. We don't know exactly what happened to his mother, but it could have been anything.

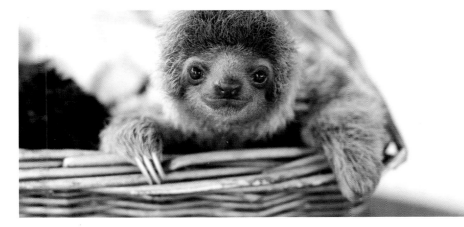

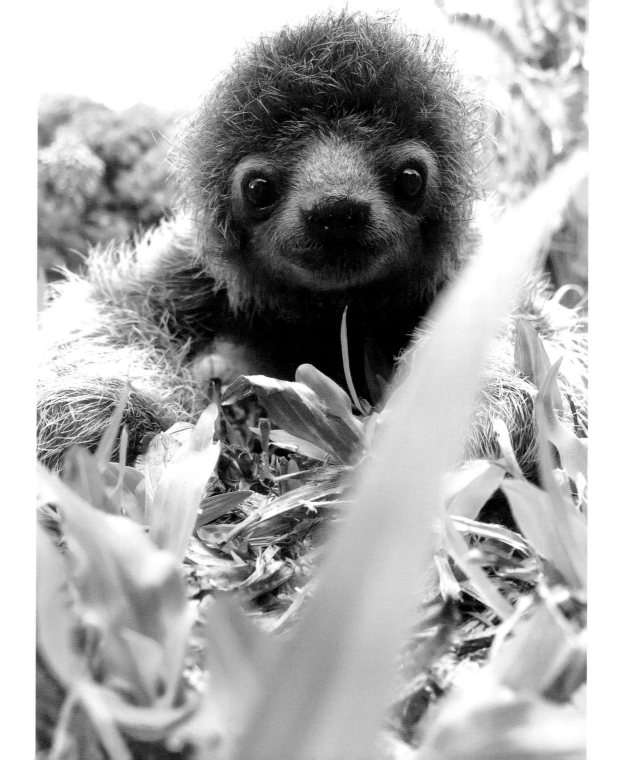

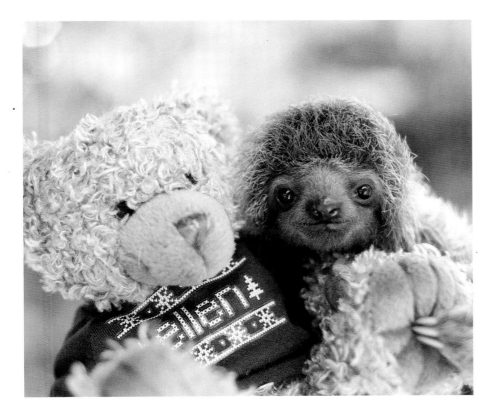

Luckily, Chuck was in good health and adapted to nursery life quickly. He gets along great with all of the other babies and spends most of his time attached to Monster. He really is one of the nicest sloths I have ever met. Because of his crazy hair and winning personality, I decided Chuck was the ideal sloth to name after my father.

Chuck is now almost four months old and still going strong. Although I'm sad that he lost his mother, I am so grateful he was found and is now with sloth friends, growing, learning, and living. He will eventually make it back out into the forest where he was born and where he will have a second chance at the life he so deserves.

Taking care of sloth babies like Chuck is what I live for now. The idea of seeing him all grown up, moving through the trees, and interacting with some lovely sloth ladies is what I dream about.

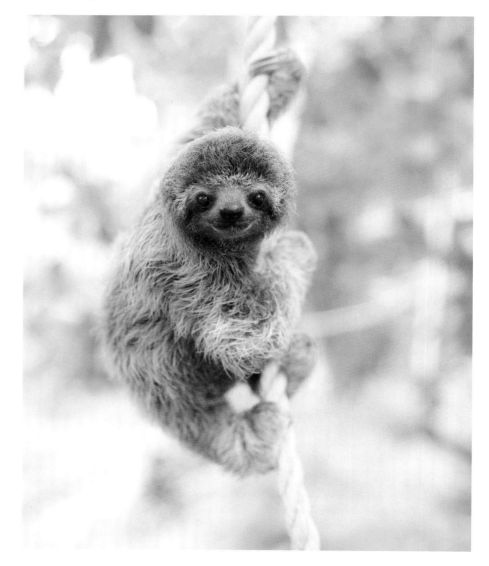

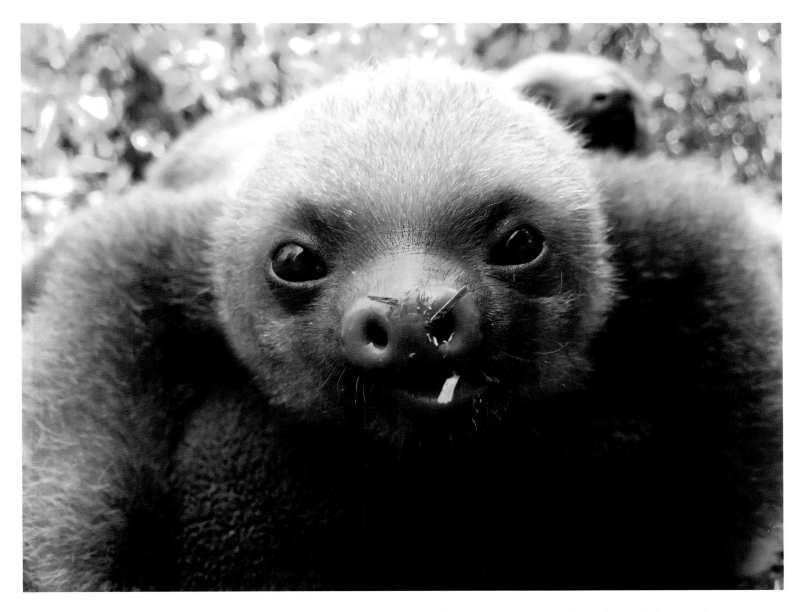

17. Two-fingered sloths sometimes eat dirt, which may help to explain why they come to the ground to defecate before or after eating.

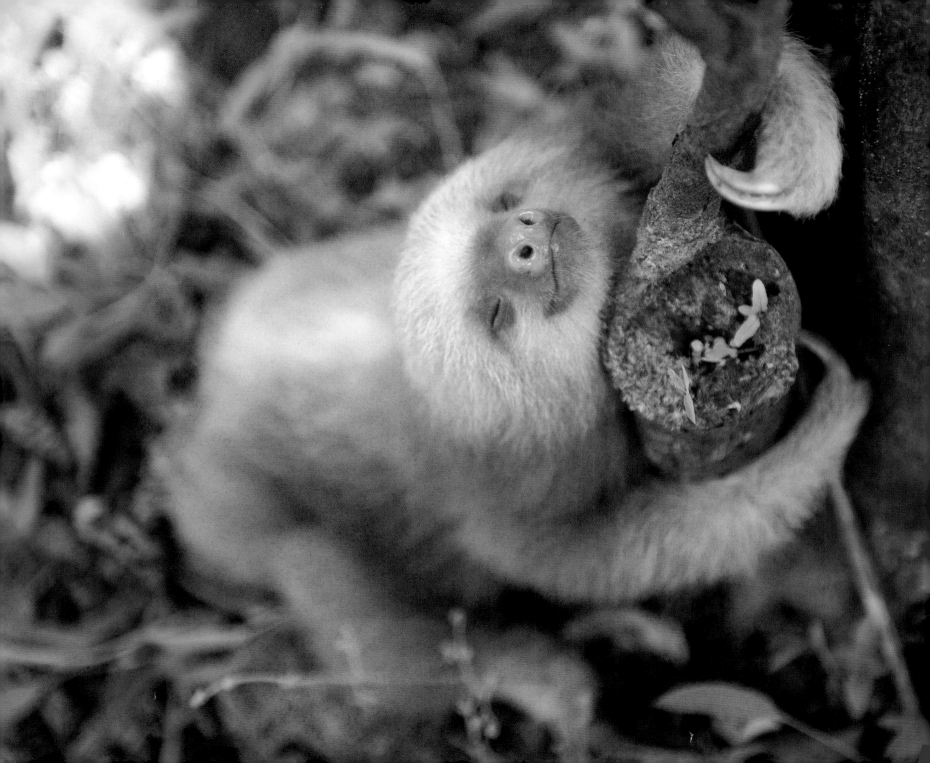

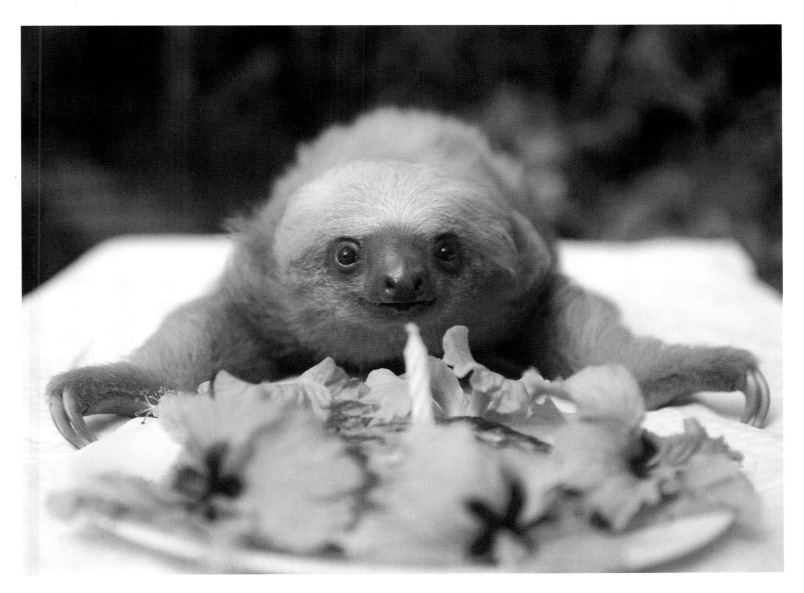

18. Sloths have relatively long life spans, long gestations, and a larger amount of maternal investment and take longer to sexually mature than other similarly sized mammals, such as raccoons and house cats. (Taube et al. 2001; Lara-Ruiz and Chiarello 2005)

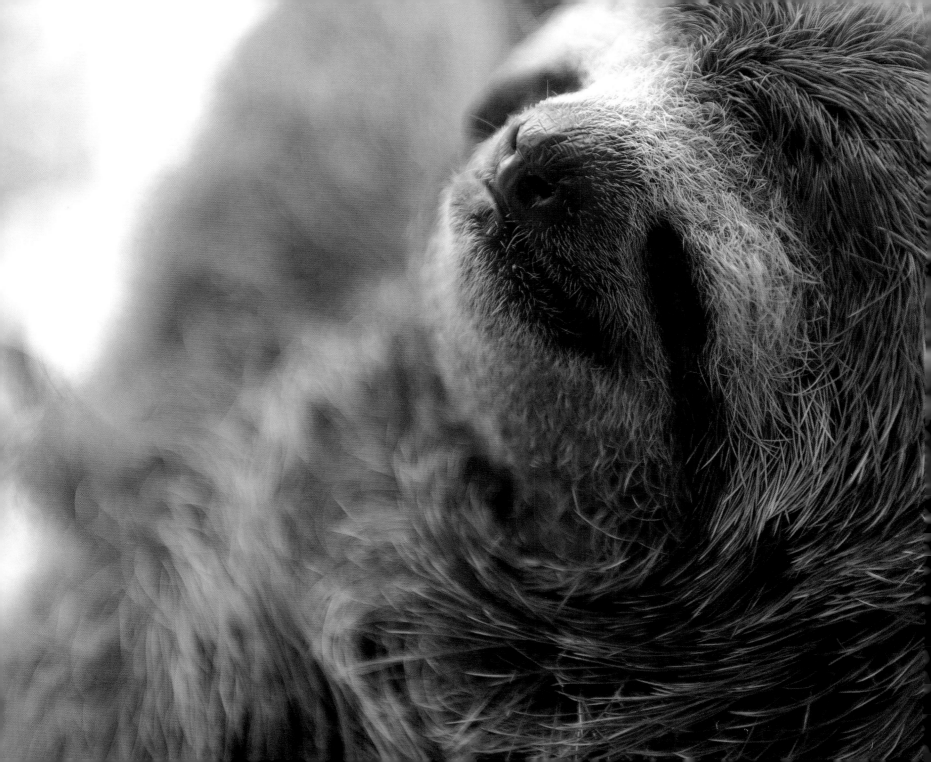

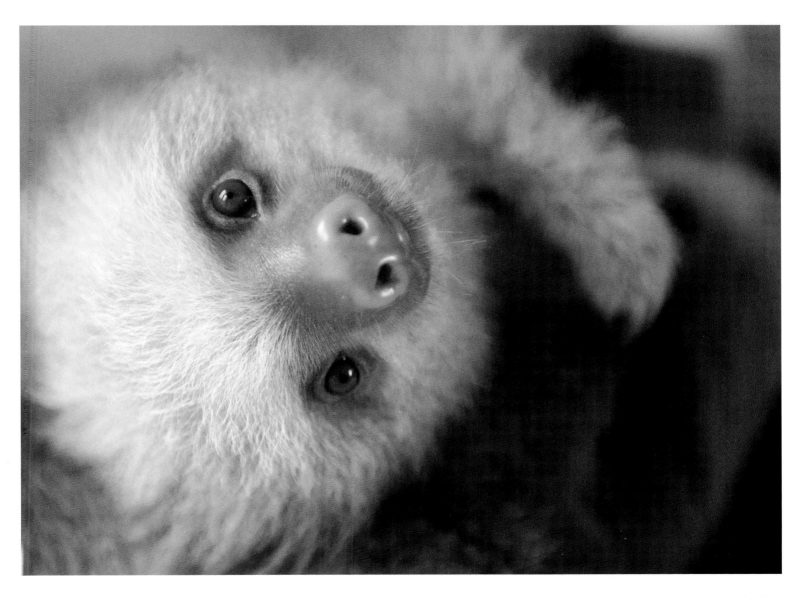

19. Although two-fingered sloths are not blind, they rely little on vision to carry out their normal behaviors and appear to be nearsighted. (Mendel, Piggins, and Fish 1985)

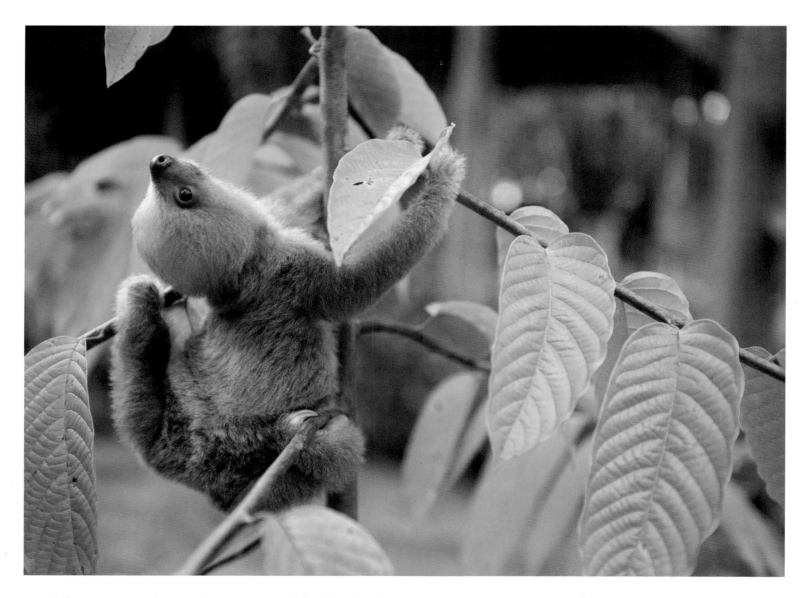

20. Sloths put yogis to shame. They are extremely flexible, which helps them move around the trees and allows them to get to food in hard-to-reach spots that would otherwise be inaccessible.

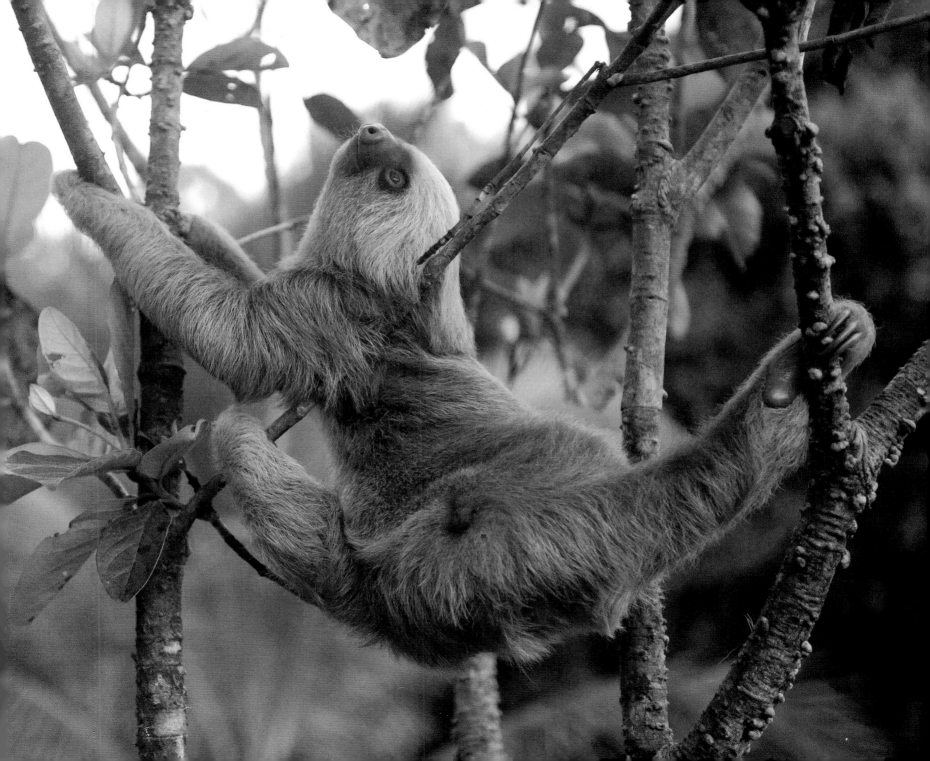

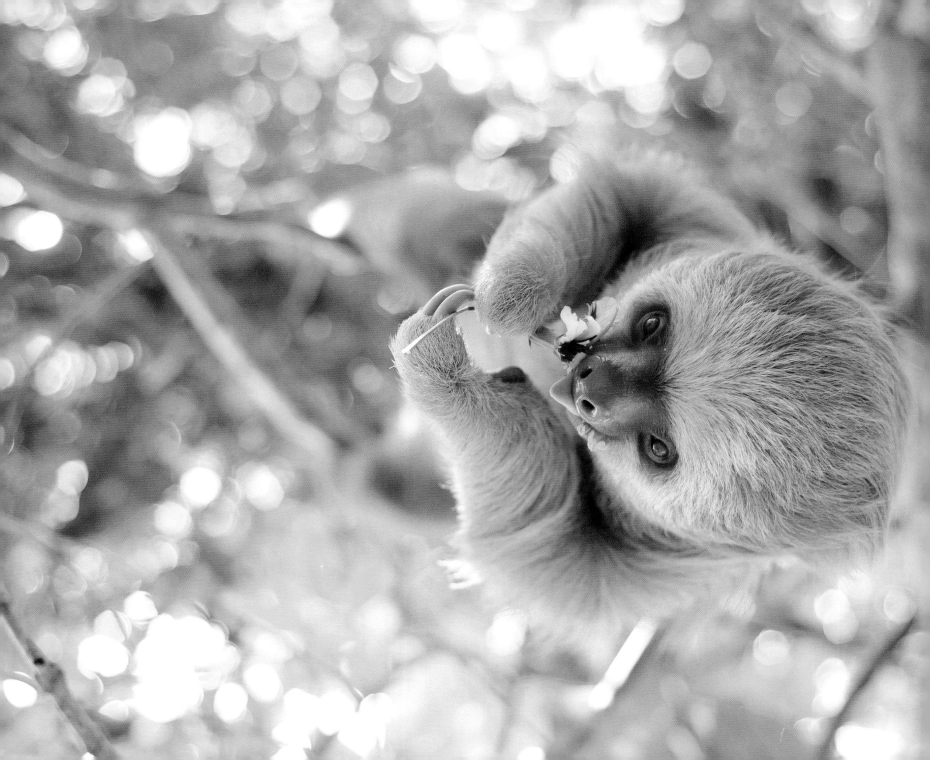

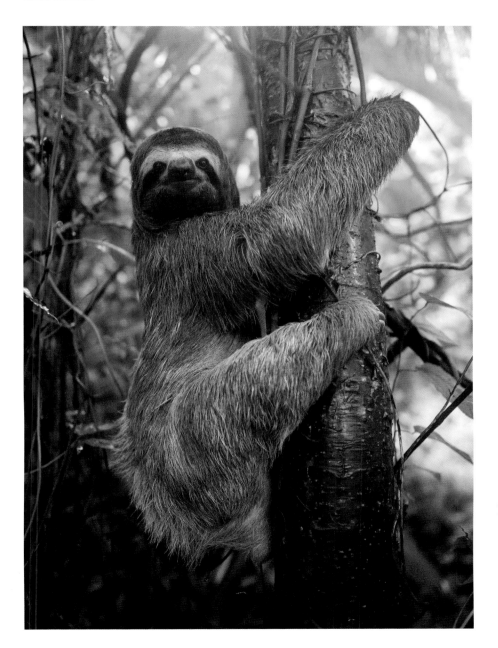

21. Widespread throughout Central and South America, sloths are highly successful at life in the forest. Their bodies are built for climbing, and their hair camouflages them perfectly in the trees. Outside of the forest they cannot survive, and so they are extremely affected by habitat destruction. (Montgomery 1985)

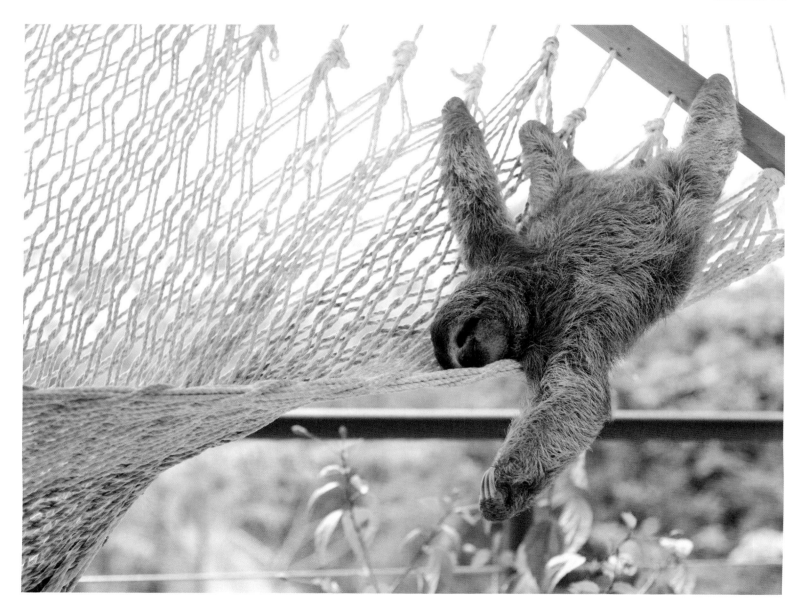

22. The Spanish word for sloth is *perezoso*, which means lazy. But they are not lazy—they are efficient.

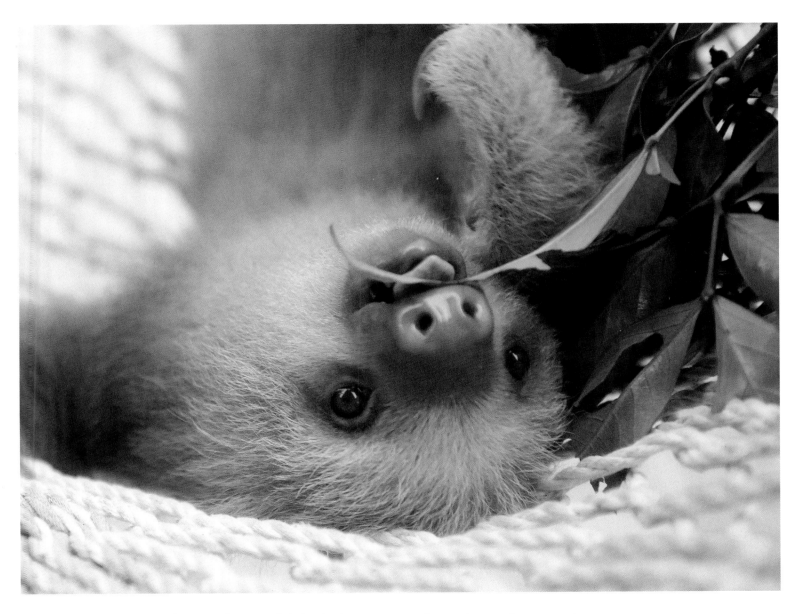

23. Because sloth diets are low in calories and sloths don't store many calories, they can't exert much energy.

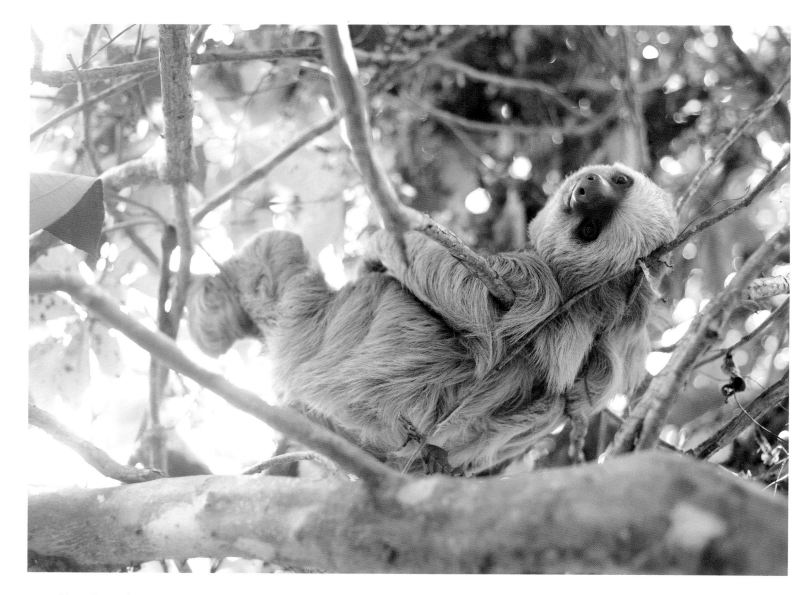

24. Although two-fingered sloths have a nasty bite, sloths in general do not have many natural defenses against predators. Their primary defense is to avoid those who want to do them harm. They are excellent at camouflage.

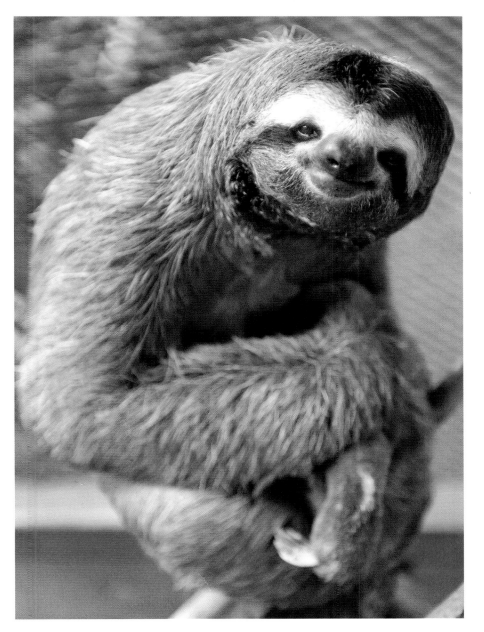

25. Sloths have hair that is structured unlike any other mammal's—they are able to grow algae on and inside their hair! This algae not only helps them to blend into the trees, but may also serve some nutritional benefit. Some research suggests sloths eat the algae off their hair, but that is inconsistent with sloth behavior. Instead, it could be that the hair acts like a straw to draw the algae close to their skin, where valuable nutrients are absorbed. (Gilmore, Da Costa, and Duarte 2001 and Pauli et al, 2014)

Kermie

Whenever I say things like "Monster is my favorite sloth," I start to feel bad because then there is Kermie—and I adore Kermie!

Kermie is the first newborn sloth I ever cared for. I had only been in Costa Rica for a little over a month when he arrived. Tiny, squishy, and wrinkly, Kermie was such a joy and also such a cause for worry. A newborn! How was I supposed to keep a newborn sloth alive?

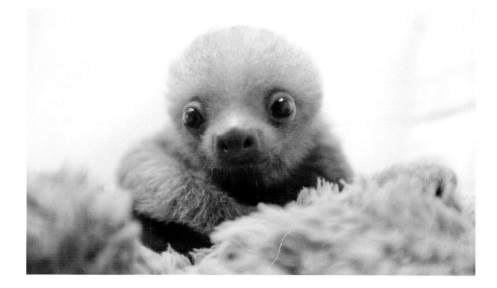

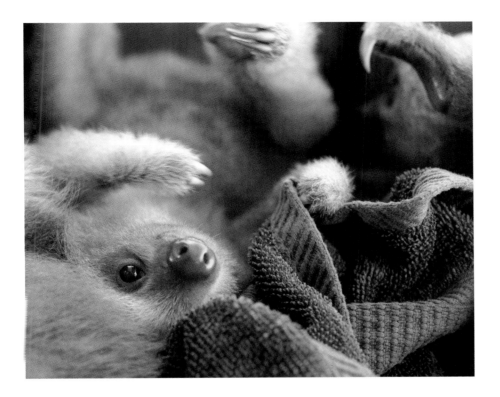

Kermie was the first baby sloth that I wrapped to my chest as if I were his real mother. I wanted to make sure he was warm and safe and felt loved. Kermie was with me practically every second of the day, and he blossomed. Now, two and a half years later, Kermie has not only grown into a full adult sloth, he is also the first sloth I hand-raised to be released. Kermie will be "soft released," meaning he will be eased into the transition of living in the jungle alone. He will first live in a large cage at the release site and be provided with food. Eventually the door to the cage will be opened, and he will be able to come and go as he pleases until he decides to live fully outside of the cage. He will also be wearing a tracking collar so he can be monitored 24/7, especially at night when he is active.

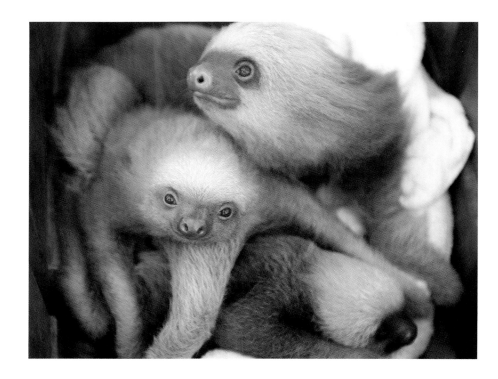

The embodiment of so many sloth firsts for me, Kermie is a great role model for all future sloth babies I will care for. Whenever we lose a sloth and I feel frustrated or feel like the work is impossible, I think of Kermie and his survivor's spirit. The fact that he's made it against such great odds proves that nothing is impossible if you work hard enough. Kermie is my reminder to never give up, and I will never give up on him.

I celebrated the first time he ate solid food, the first time he climbed a tree, the first time he met another sloth, the first time he climbed down a tree and pooped on his own, the first time he was rained on, and the first time he spent the night outside without me. Right now he is wearing his tracking collar and soon—together—we will celebrate the first time his lungs fill with air as a *free* sloth.

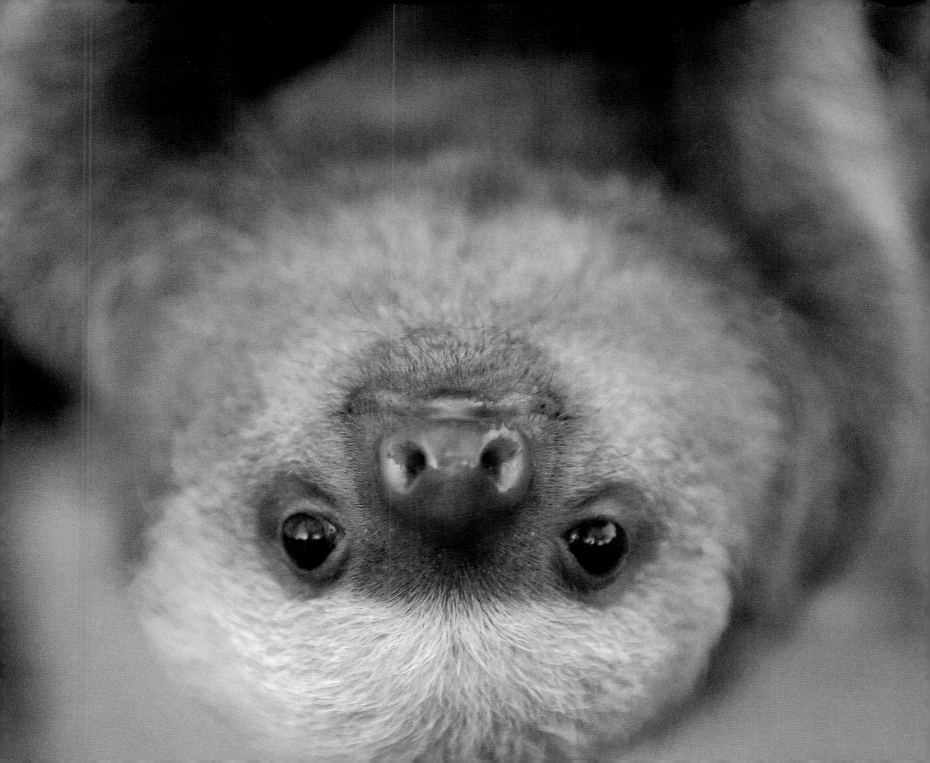

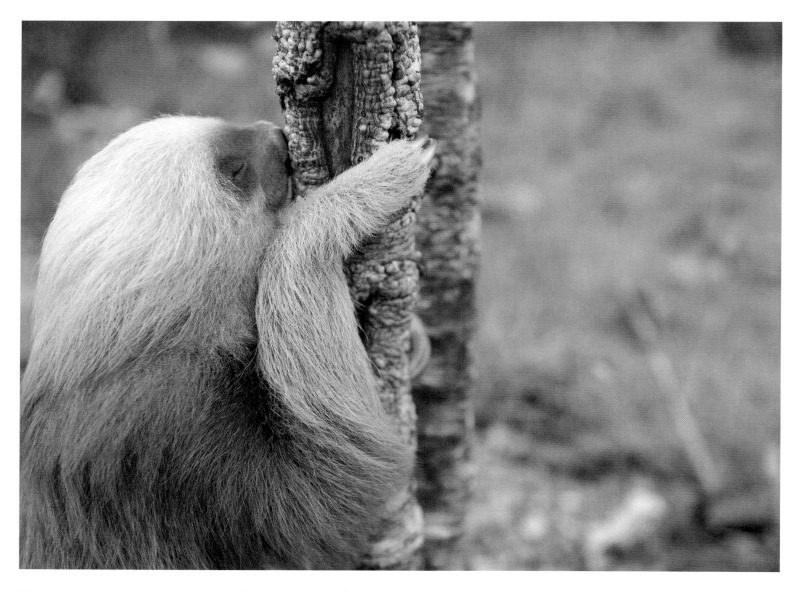

26. In addition to algae, sloth hair absorbs water and smells and retains them for weeks. For this reason, people who work with sloths cannot wear perfume, bug spray, or lotions.

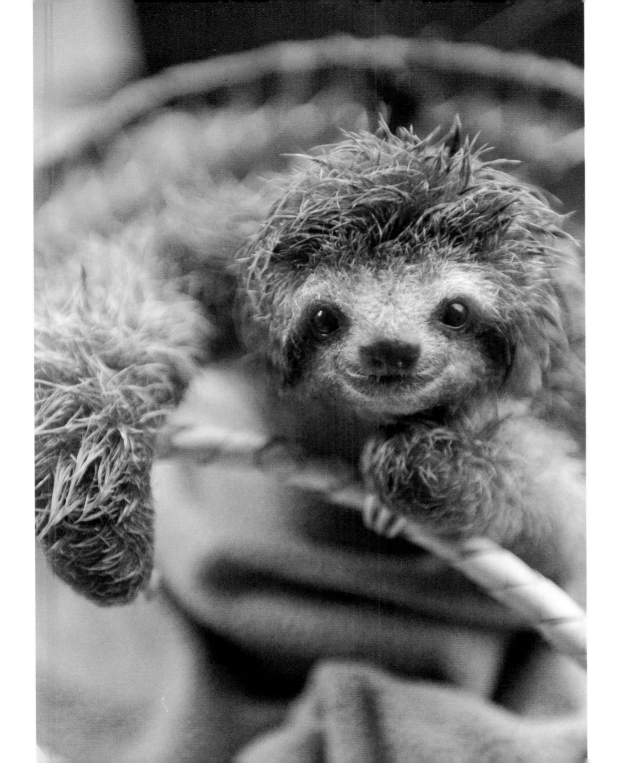

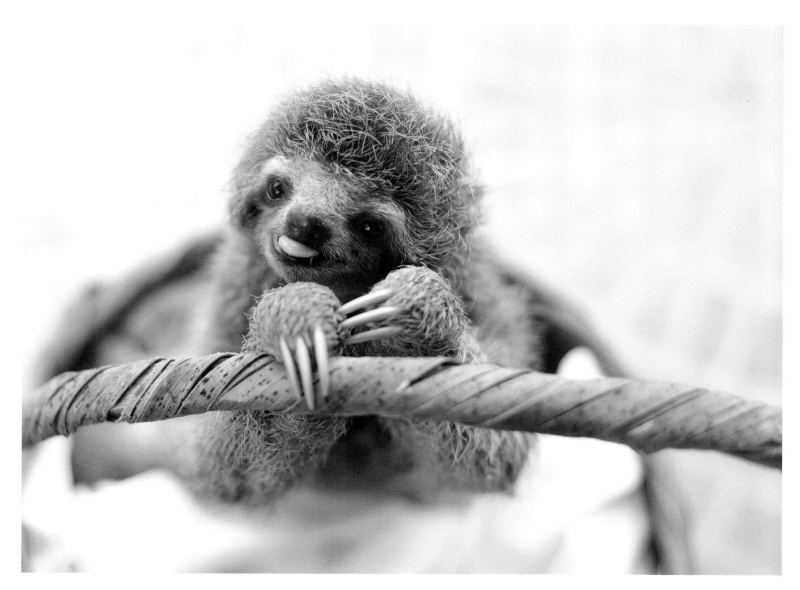

27. When baby sloths are scared, they cry to attract their mothers to where they are located. Although these cries may sound cute to a naive observer, they are a signal the sloth is stressed and are actually heartbreaking to hear!

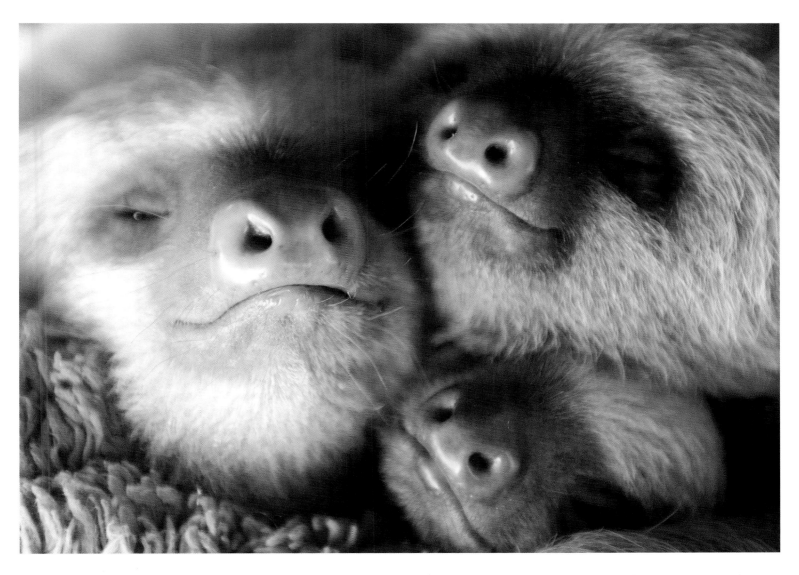

28. Sloths are classified by scientists as "solitary," but their social system isn't well understood. They are very difficult to observe in the wild because of their elusive behaviors and ability to hide. Preliminary observations suggest that their social systems are much more complex than previously thought.

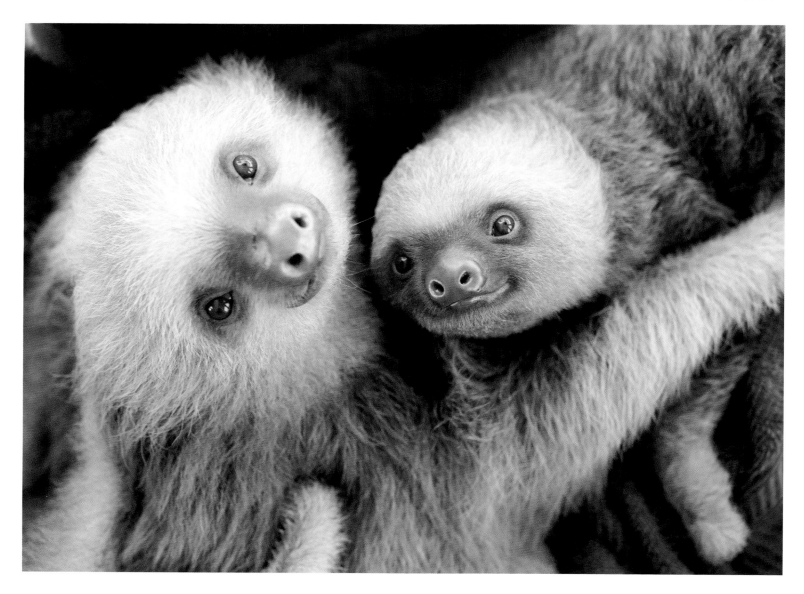

29. You can tell if a sloth is excited, stressed, or in pain by the size of their pupils. Larger pupils during the bright daytime means something is going down!

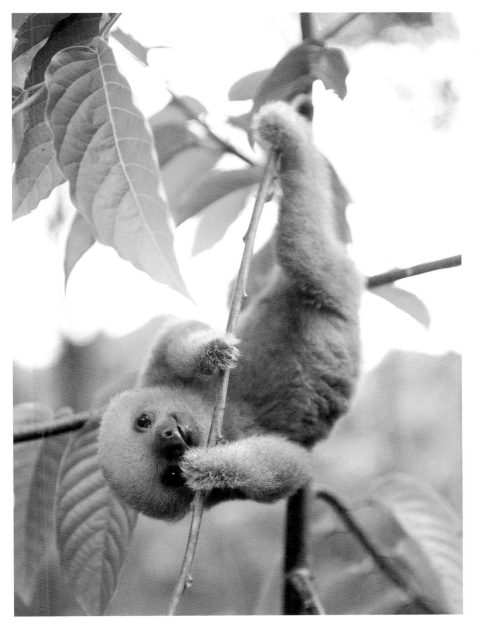

30. A sloth's "smile" is permanent because of their lack of expressive facial muscles. It is not a reflection of their level of happiness. In fact, they get stressed very easily, despite their smiles.

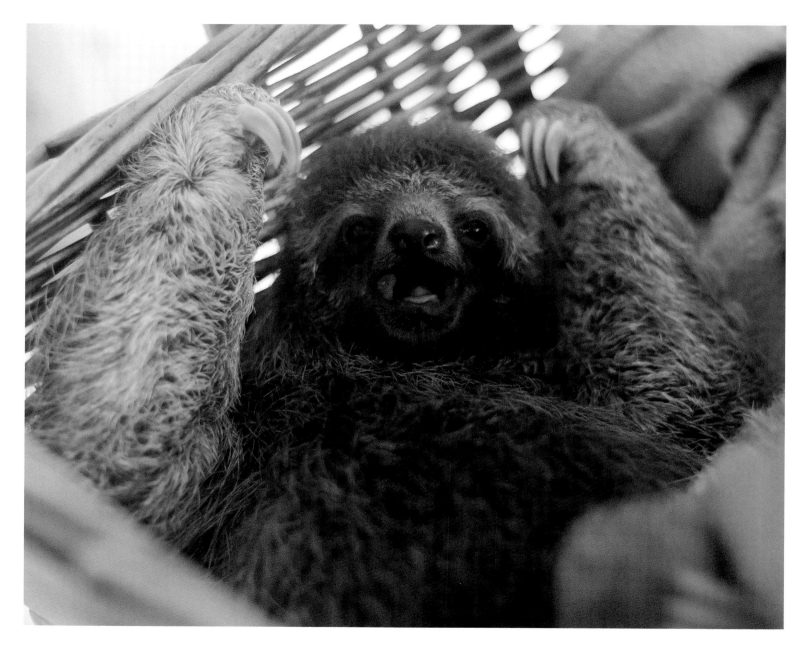

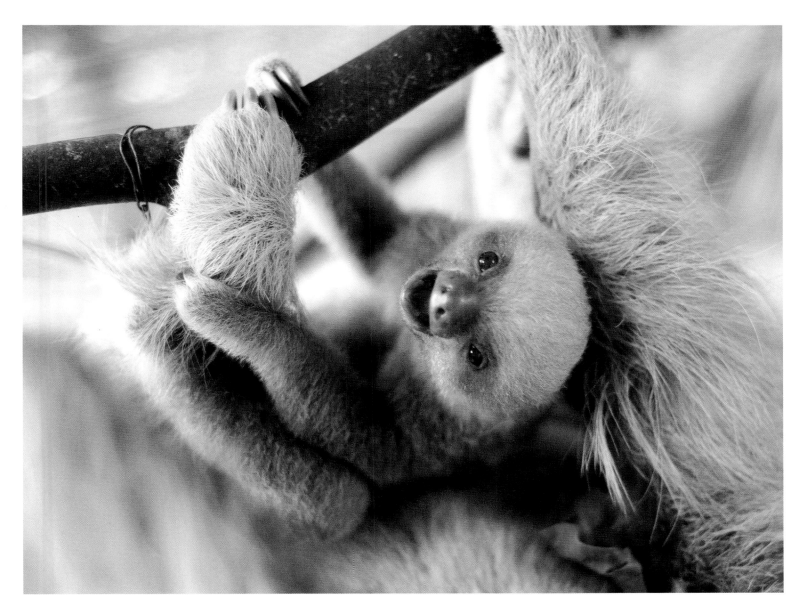

31. Sloths, especially the young ones, love to play. When playing, they wrestle, swat, and display an open-mouthed play-face.

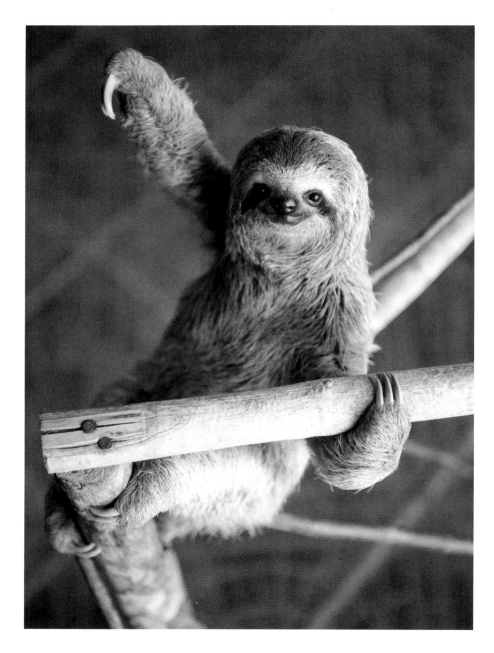

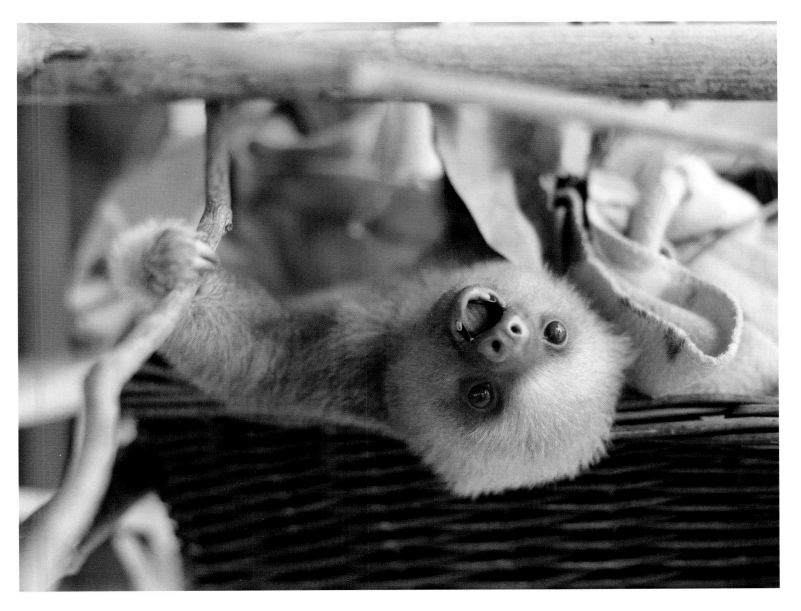

32. Angry sloths will hiss loudly and swat aggressively with their arms up, displaying a defensive posture as a warning to leave them alone.

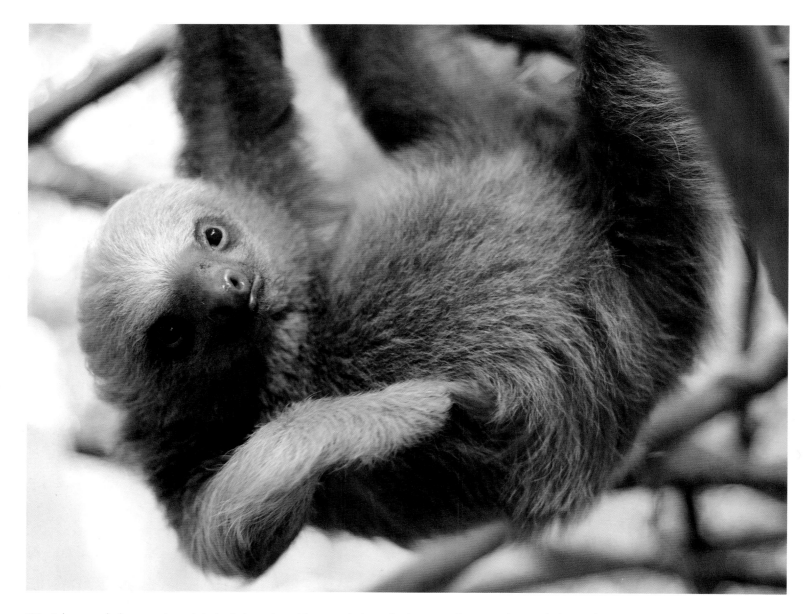

33. A happy sloth is a relaxed sloth. Relaxed and happy sloths will often stretch out and scratch themselves.

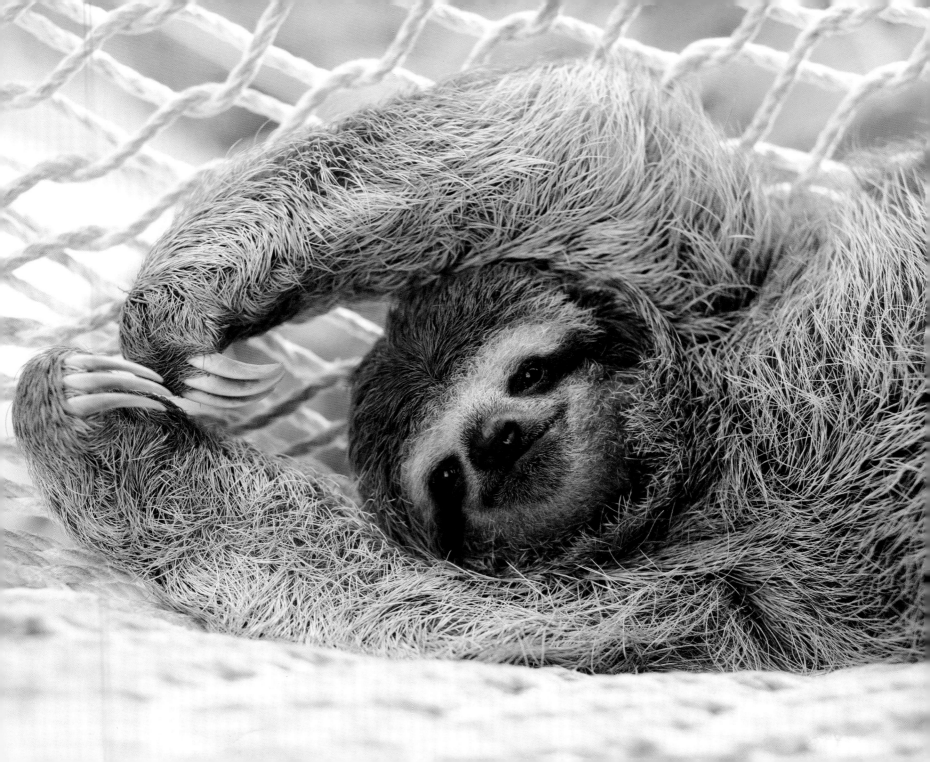

Elvis

I've always been a huge Elvis fan. As a young child I religiously watched Elvis Week on television each August with my dad. The small version of me could not resist Elvis's rhythm and magnetic personality. Although I was not alive while Elvis was alive, he made an impression on me nonetheless, and I've always wanted to name an animal after him.

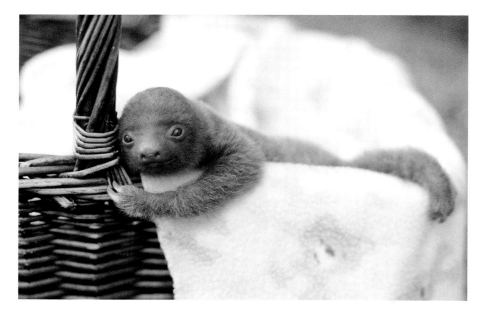

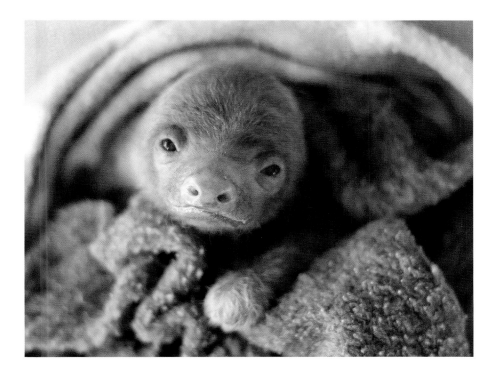

Fast-forward to present day. When a tiny newborn two-fingered sloth arrived at the rescue center, my first thought was *this is going to be a tough one*. Time and experience have taught me that newborns are particularly difficult. You have to spend every waking minute with them, making them feel safe, secure, and loved.

It's hard to get them to drink milk. Just like some human babies, sloth babies aren't always very good at nursing. Sometimes they just don't know what to do, and that coupled with the fact that they are learning with an alien (me) and a crazy alien device (syringe and plastic nipple) makes it even *more* difficult to get them nursing and drinking milk as they should. However, with enough patience and about zero sleep on my part, sometimes magic happens and things just click.

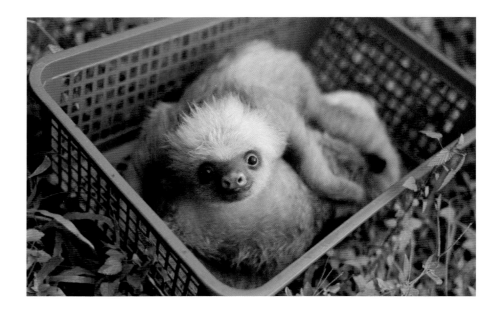

Once Elvis started thriving, I realized I had to give him a name. Of course, everyone around me had suggestions. I mean, who doesn't want to name a baby sloth? But as soon as the name "Elvis" popped into my head, I knew it was the one. After all, he was very handsome, very tender—likely a twin as he was born extremely small (only 7 ounces / 200 grams, while the average birth weight for two-fingered sloths is closer to 12 ounces / 350 grams)—and had some seriously flexible hips. As he's gotten older, his hair has become even more Elvis-like.

Elvis is now seven months old. He's much bigger and lives with his adopted brother Bruno (after Bruno Mars—I think I like the musician theme). He is still just as tender, although the two have been caught rough-housing from time to time, especially with a rainstorm as their background music. About a year and a half from now, Elvis should be ready for release—swaying his hips through the trees as he climbs away from me and away from his life with a human mom.

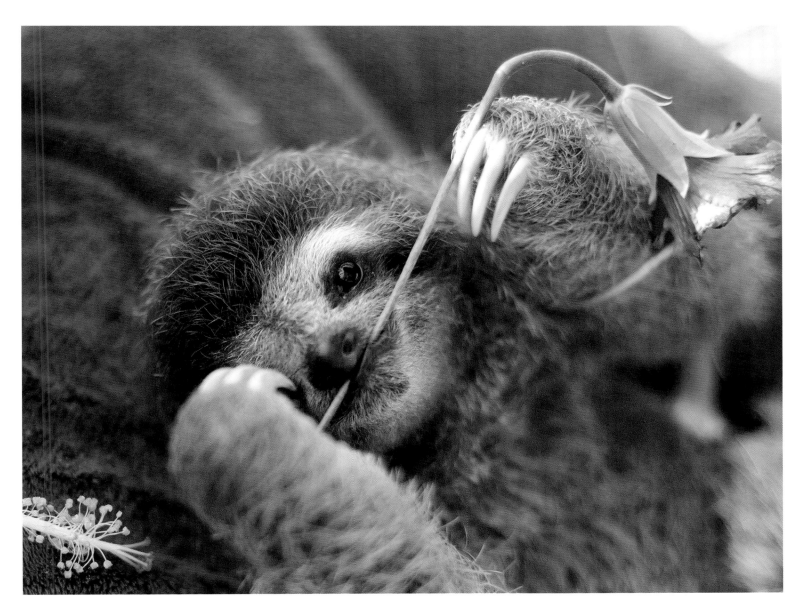

34. Three-fingered sloths are strict herbivores. They only eat plant material.

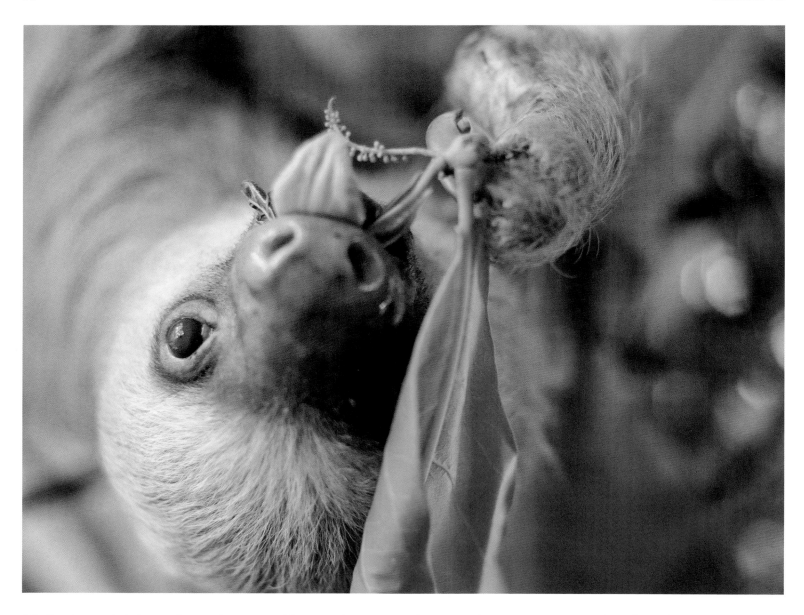

35. Two-fingered sloths mostly eat plant material but can also eat animal matter such as eggs, insects, and small vertebrates.

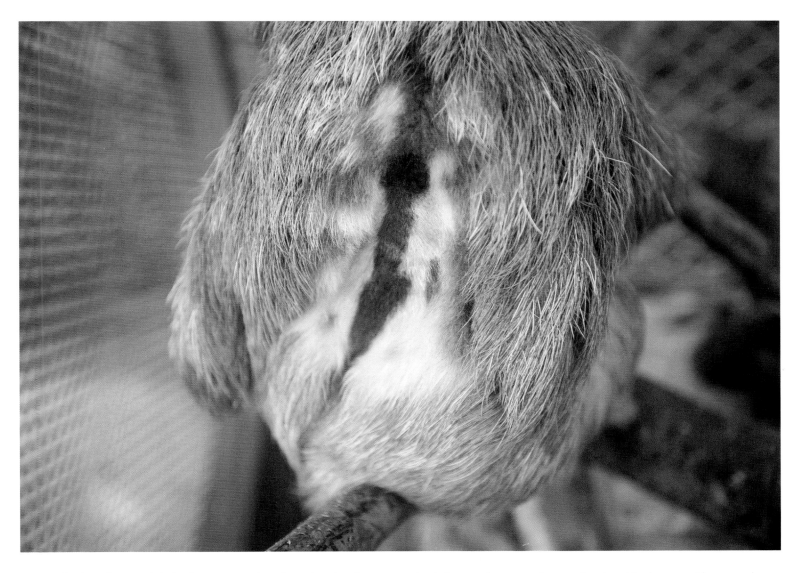

36. Male three-fingered sloths have "speculums" on their backs—a patch of short, soft orange hair with a big black stripe. The speculum is usually noticeable at birth but becomes much more obvious as they sexually mature. This is helpful in identifying the sex of a sloth, because they do not have any obvious external genitalia.

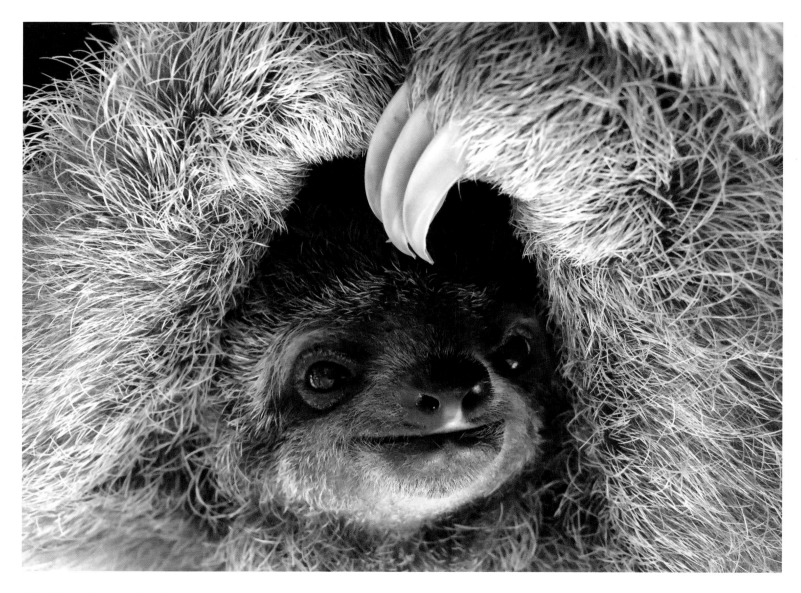

37. When sloths are first born, their claws are basically transparent—you can see the pink blood beneath the surface. As they age, this pink disappears and the claws become a solid eggshell color.

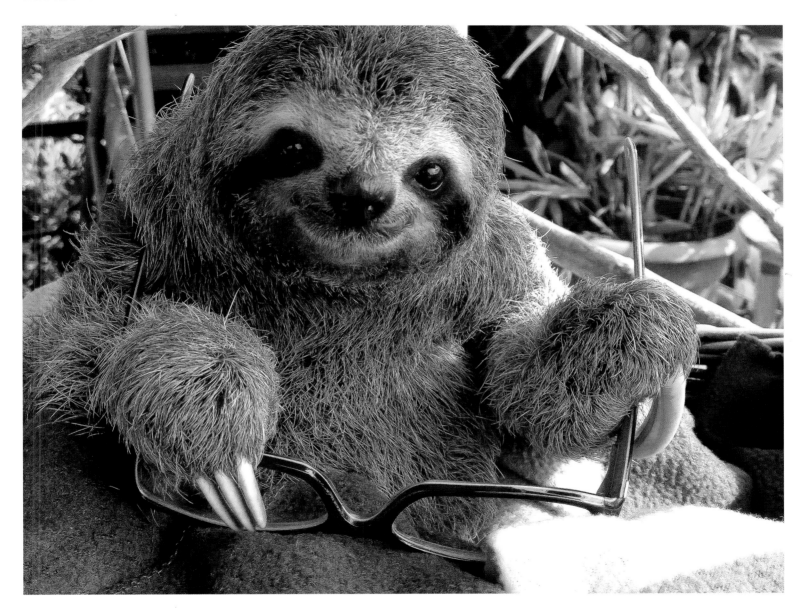

38. Sloths are very curious. They are often drawn to mirrors and phones and will even pull the glasses right off your face!

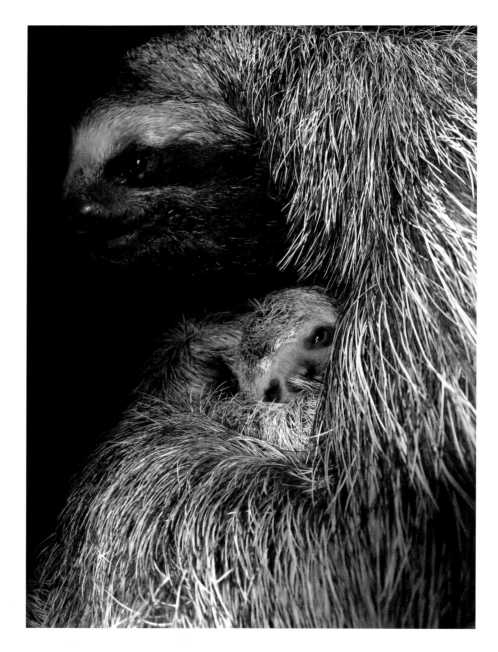

39. Baby sloths are very dependent on their mothers for the first year or two of life. They ride on their mother's stomach and back, observing her movements and learning where to find food and how to live in the trees. (Montgomery 1985)

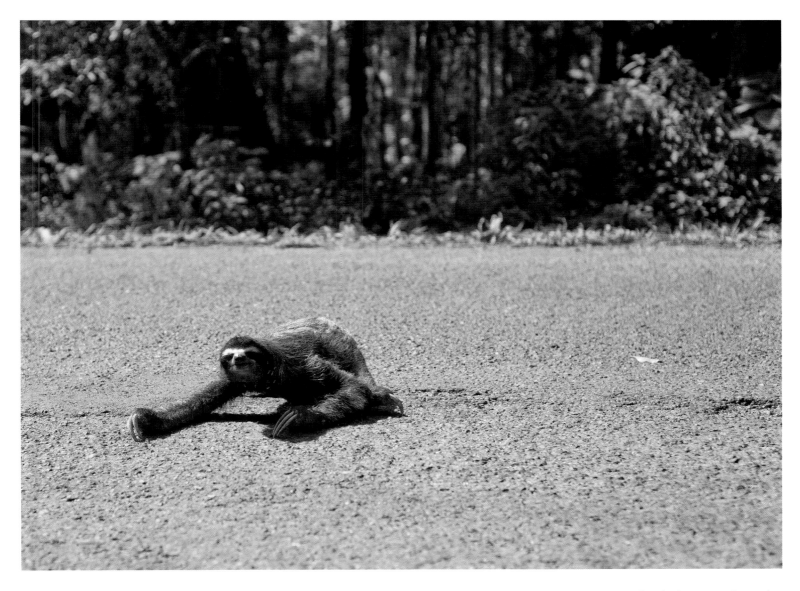

40. Sloth habitat is disappearing due to human encroachment. Sloths do not adapt well when having to contend with dogs, roads, and electric wires.

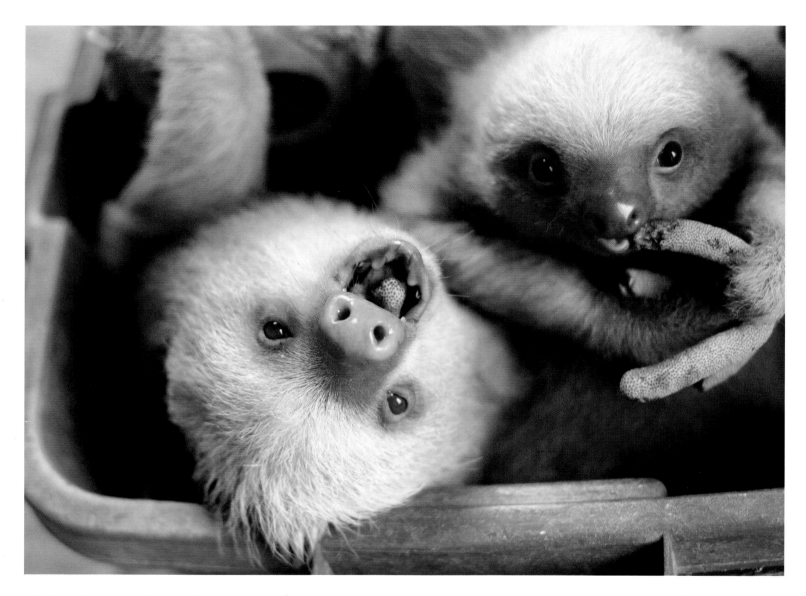

41. Sloths love to eat hibiscus flowers, young cinnamon-tree leaves, and the fruit from *Cecropia* trees, and they are really good at sharing food.

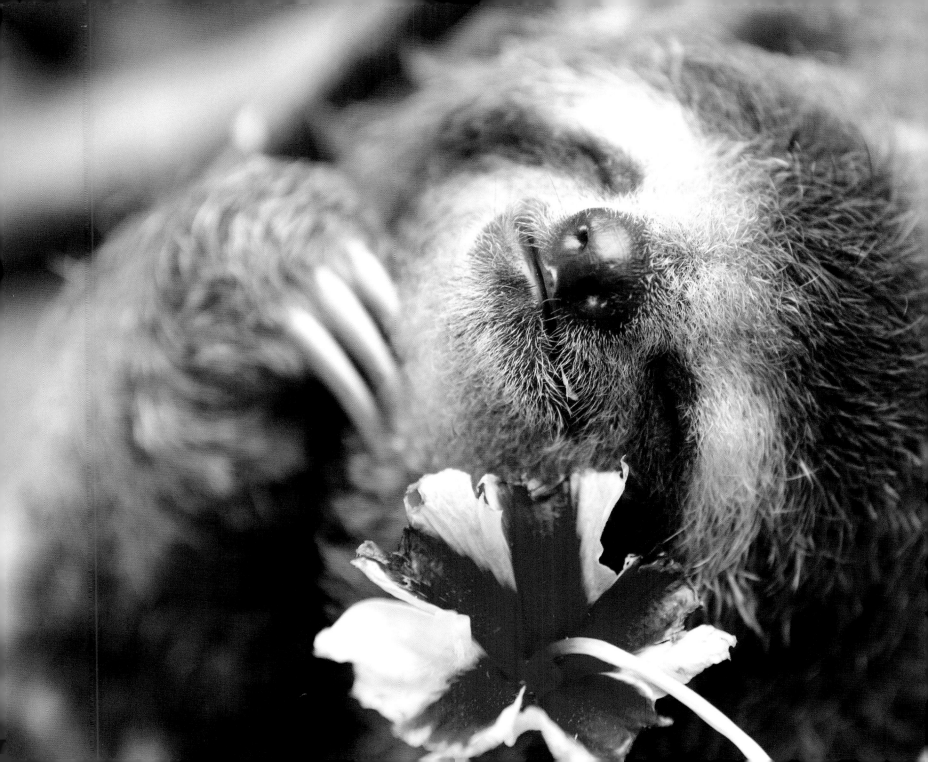

Monster

Ode to Monster:
There has never been,
Nor will there ever be . . .
A more important face to me.

I often refer to Monster as my slothy soulmate. Weighing little more than half a pound, she arrived at the KSTR rescue center alone and crying about a year and a half ago. She was so tiny and delicate that when I first picked her up, I let out an audible squeal. I don't think I had ever held anything so adorable before. More than just that, she was helpless. This tiny little girl had been found trying to cross a road all alone, looking for her mother and crying out in hopes that her mom would hear her and find her.

The first night she was in my care, I tried desperately to console her. I held her and walked around with her, doing anything and everything to keep her quiet. Nothing worked. She wanted her mother, and she was going to tear my house apart looking for her. She climbed the curtains and

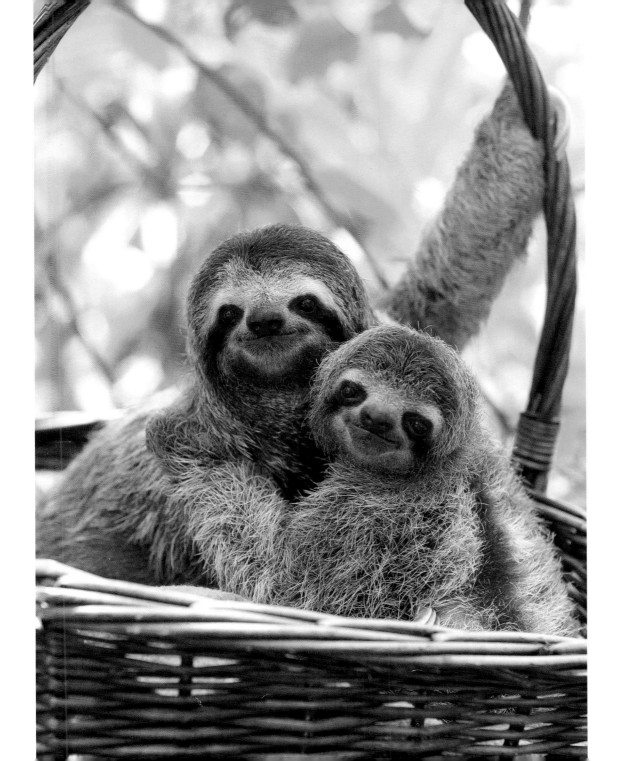

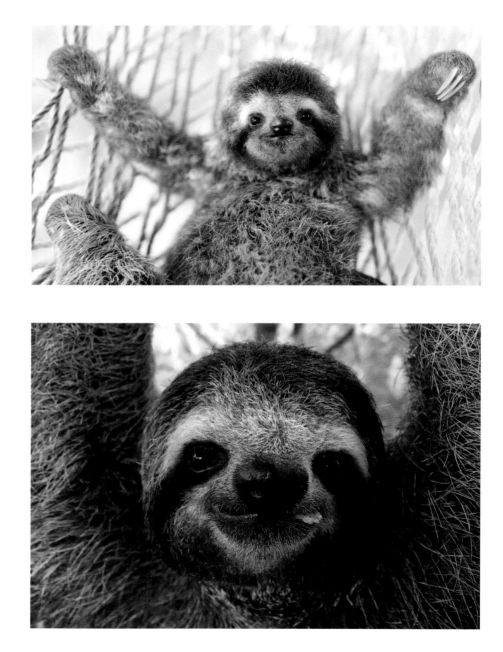

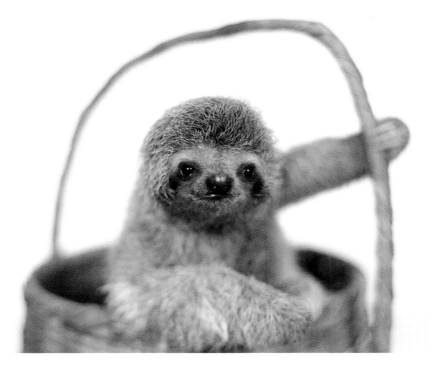

crawled on the floor. She was so upset that staying with her all night meant I didn't sleep more than a few minutes at a time.

The next morning I ran into one of the volunteers, who innocently asked, "How's the new baby?" I looked at her with sandpaper eyes and yelled in frustration, "This sloth is a monster!" The name just kind of stuck, and before we knew it, the sweetest, most amazing sloth ever . . . was named Monster.

Far from a monster now, this young lady will no doubt grow up to be a wonderful mother one day. She is very attentive with all the younger babies in the nursery and not only lets Chuck ride around on her, but sometimes even encourages him. Her favorite foods are hibiscus flowers, cinnamon leaves, and *guarumo* fruit.

Monster is going to be released very softly when she is about two years old. She'll live first inside a cage at the release site. While she acclimates to her new environment, she will be given all her favorite foods. Then the door will be opened, and she will be free to make her own decisions.

However, I won't be far behind! Monster will be wearing a very high frequency (VHF) tracking collar so we can stay aware of where she is at all times. This way we can make sure she is safe and also compare her behavior and dietary selections with that of wild three-fingered sloths in the same area.

Monster and I have spent a lot of time together, and I've been her mother for most of her life. Our bond is quite strong. She is playful, loving, curious, smart, and drop-dead perfect. Her face inspires Slothlove, and she just might be my favorite sloth ever (but shhhh . . . don't say that too loud!).

OK, the truth is, she is obviously my favorite sloth.

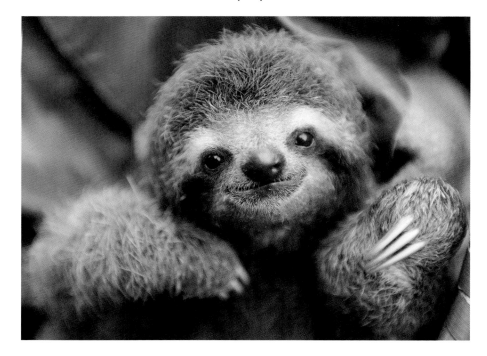

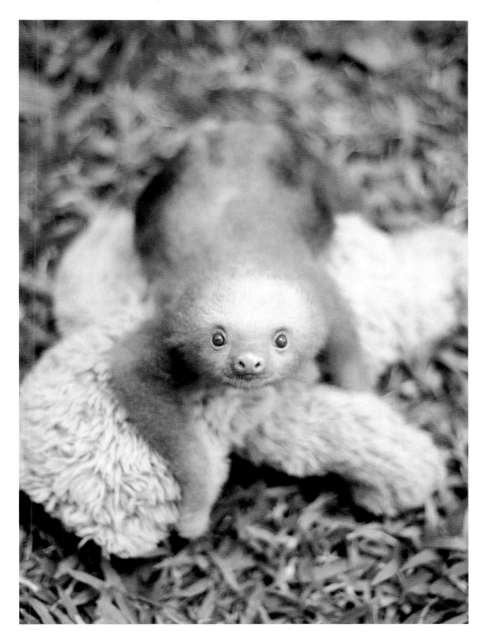

42. Baby sloths are excellent cuddlers and pretty much cuddle something all the time—whether it is another sloth, a stuffed animal, or a tree branch. The ability to clutch tightly onto their mother from the moment they are born keeps them safe and warm.

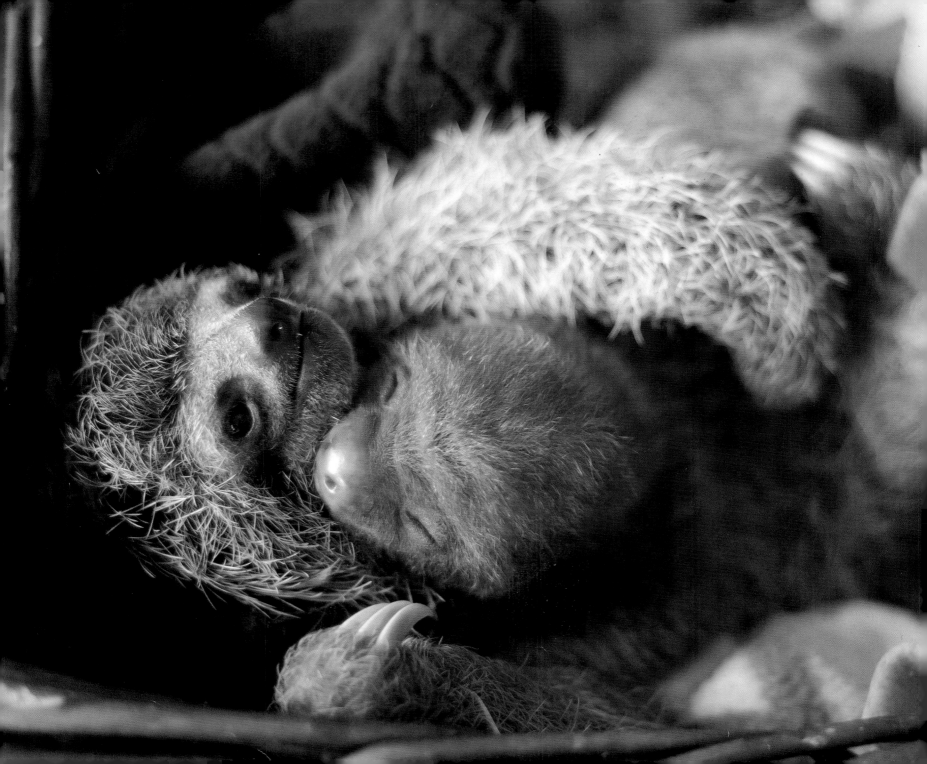

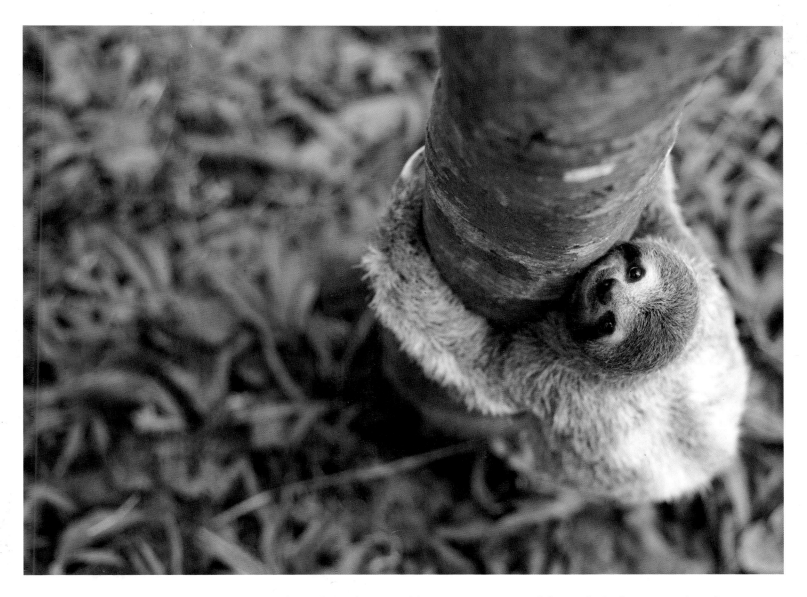

43. Sloths come down to the ground to relieve themselves. They are able to wait up to a week for each "bathroom" trip but often go more frequently (every day or every other day) in captivity, when provided with enough food, water, warmth, and exercise.

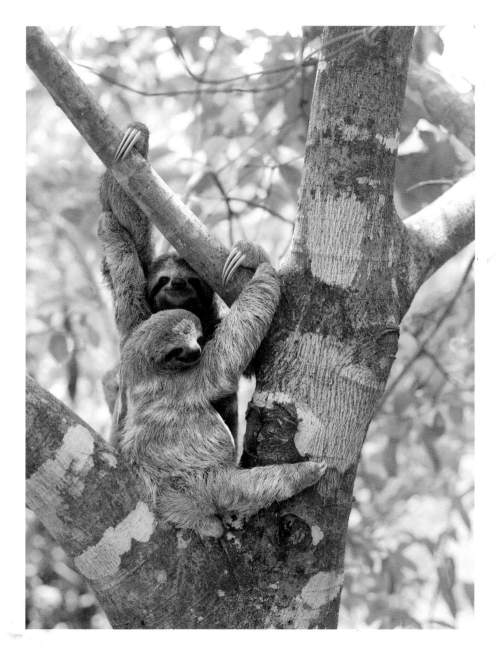

44. Sloths are great climbers and have evolved very specifically to live in trees. On the ground they look extremely awkward and become vulnerable.

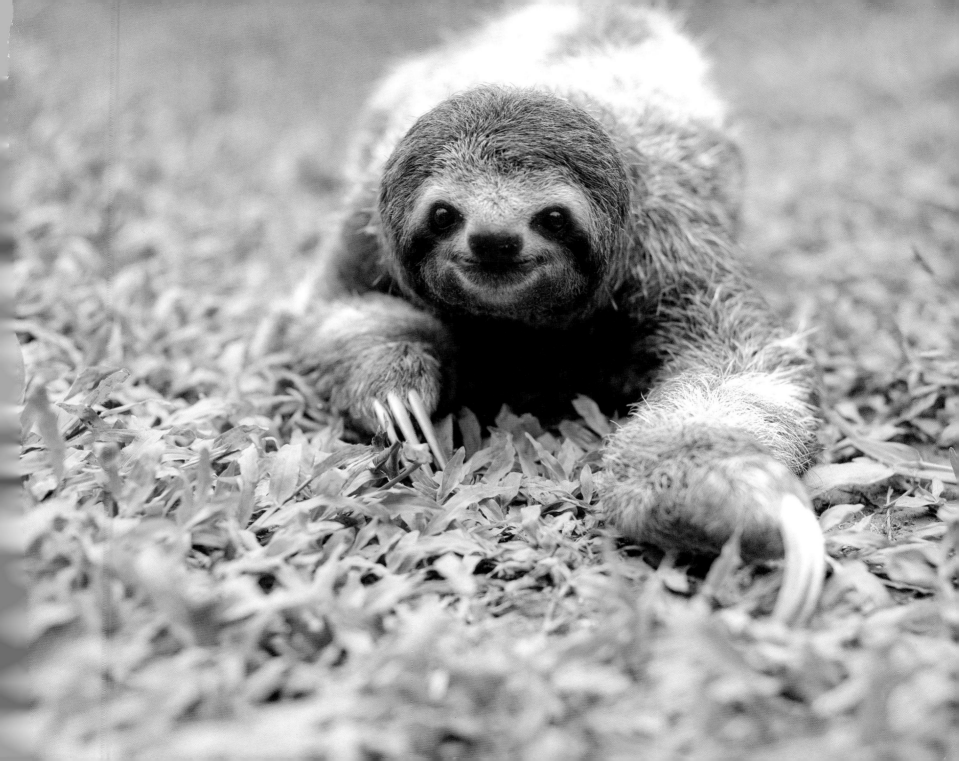

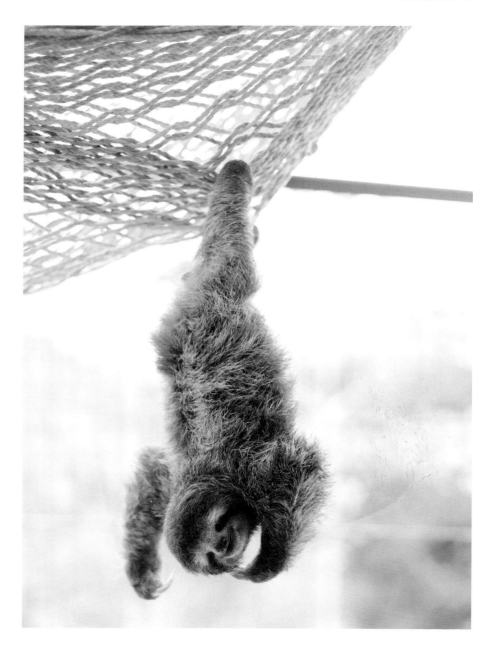

45. Because of the way their tendons are formed, sloths exert little to no energy when they are hanging in a tree. (Gilmore, Da Costa, and Duarte 2001)

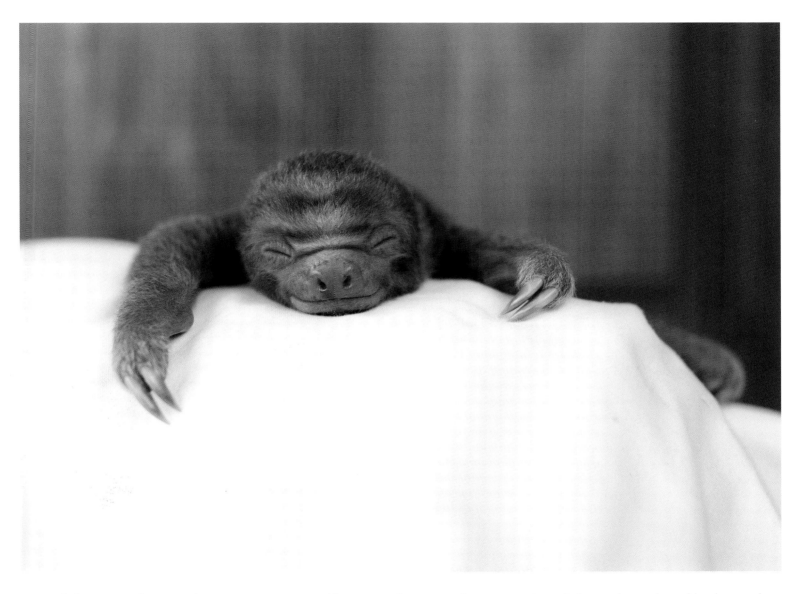

46. A sloth's strategy for survival is to conserve energy. Almost everything special or unique about sloths can be explained by this need to save energy.

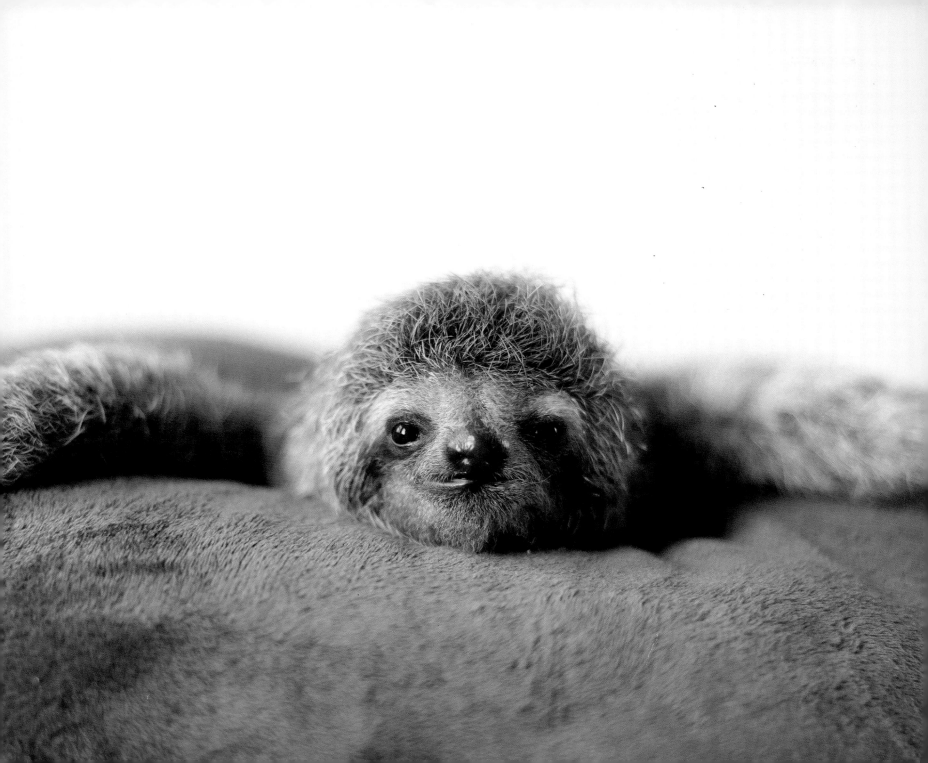

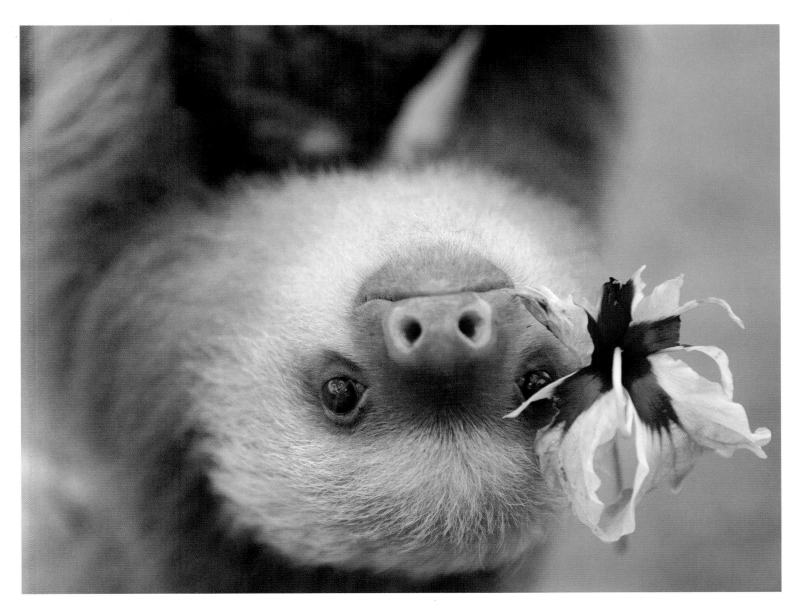

47. Sloths have the slowest metabolism of any mammal. (Gilmore, Da Costa, and Duarte 2001)

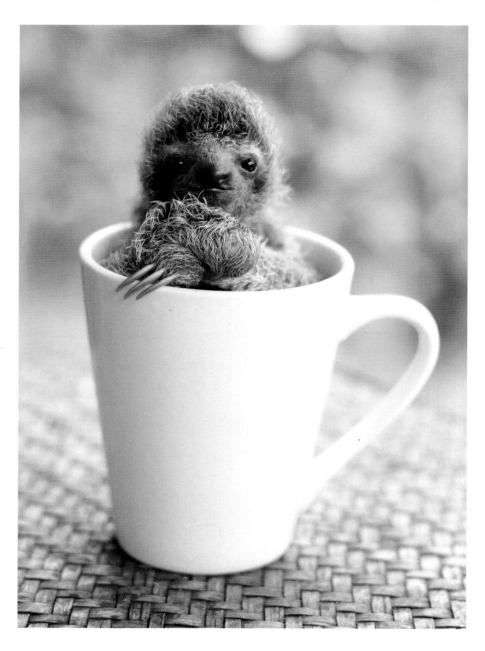

48. Sloths may lose up to 30 percent of their body
 weight when they relieve themselves.

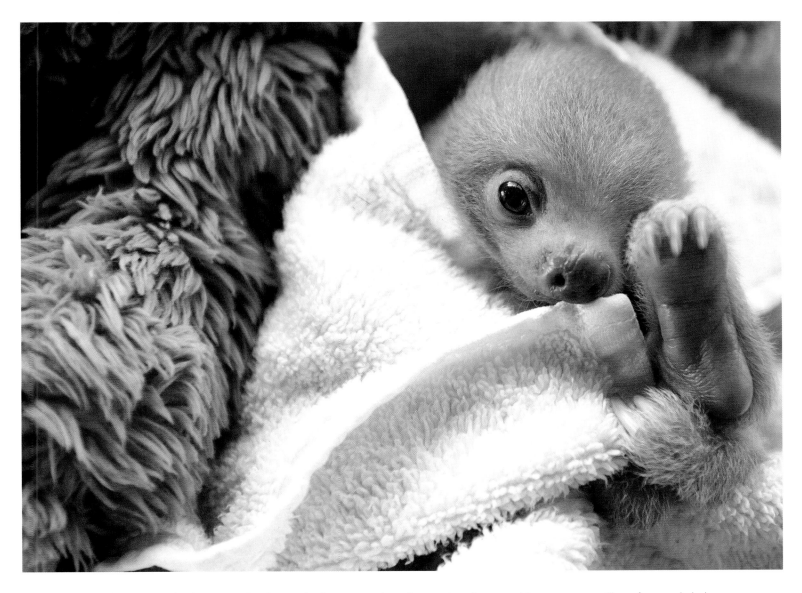

5⊃. Sloths are almost completely covered in hair, which protects them from itchy plants and biting insects. Three-fingered sloths are covered with hair except for their noses, while two-fingered sloths have hairless faces, palms, and soles of their feet.

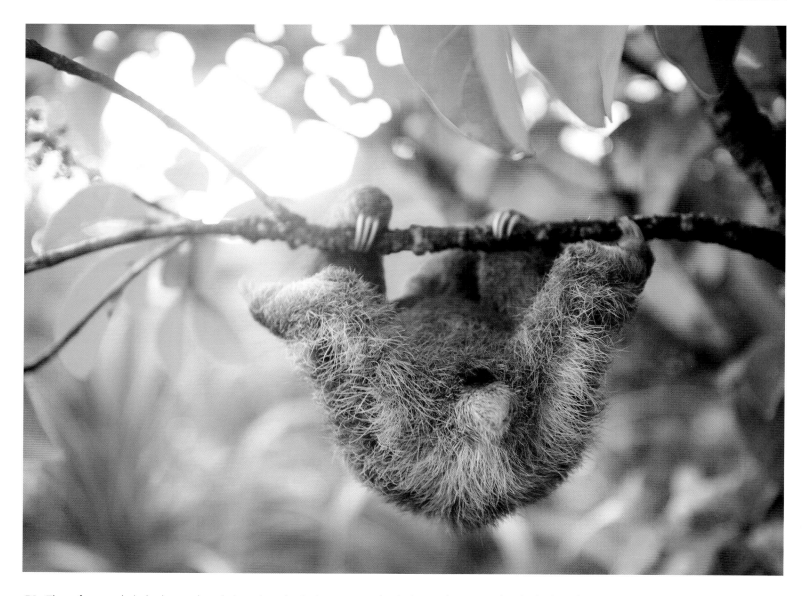

51. Three-fingered sloths have short little tails, which they use to dig holes in the ground to hide their feces. Two-fingered sloths lack a true, functional tail, though they do have a very small tailbone that can move—but you can't really see it.

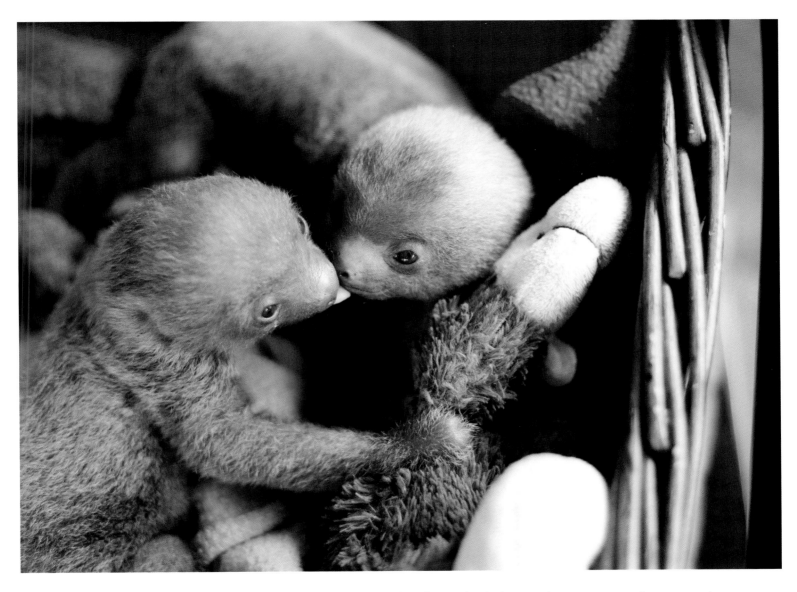

52. Two-fingered sloths show affection by kissing. Their kisses may also allow individuals to exchange important bacteria and enzymes, which could aid in digestion.

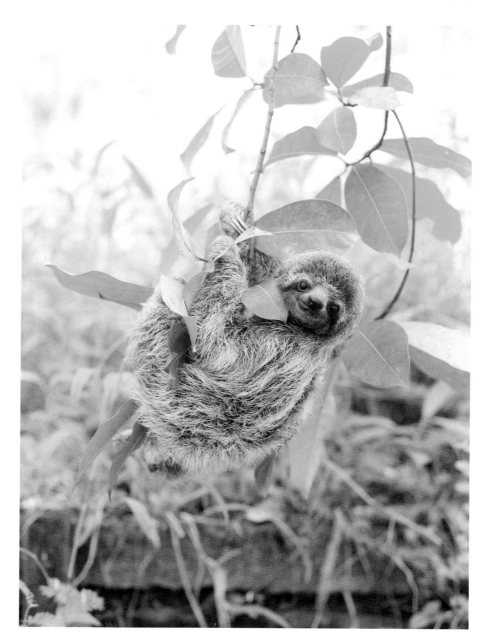

53. Sloths are very careful while climbing to avoid
 falling. They will make sure they have three
 limbs secure on a new branch before letting go
 of the last one.

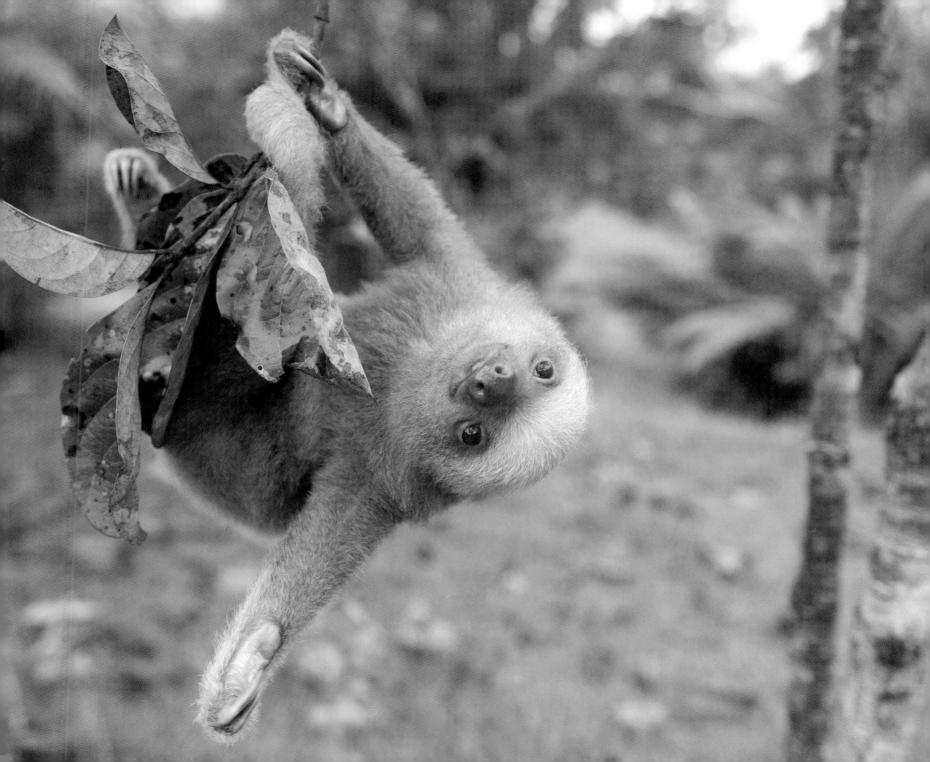

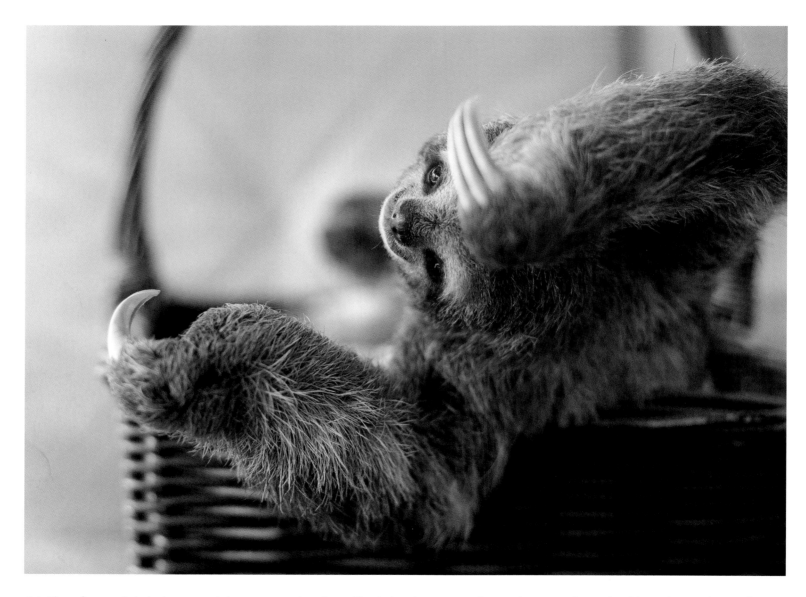

54. Three-fingered sloths have much longer arms than legs. This helps them to reach tasty leaves at the ends of branches and cross from one tree to the next in the forest canopy.

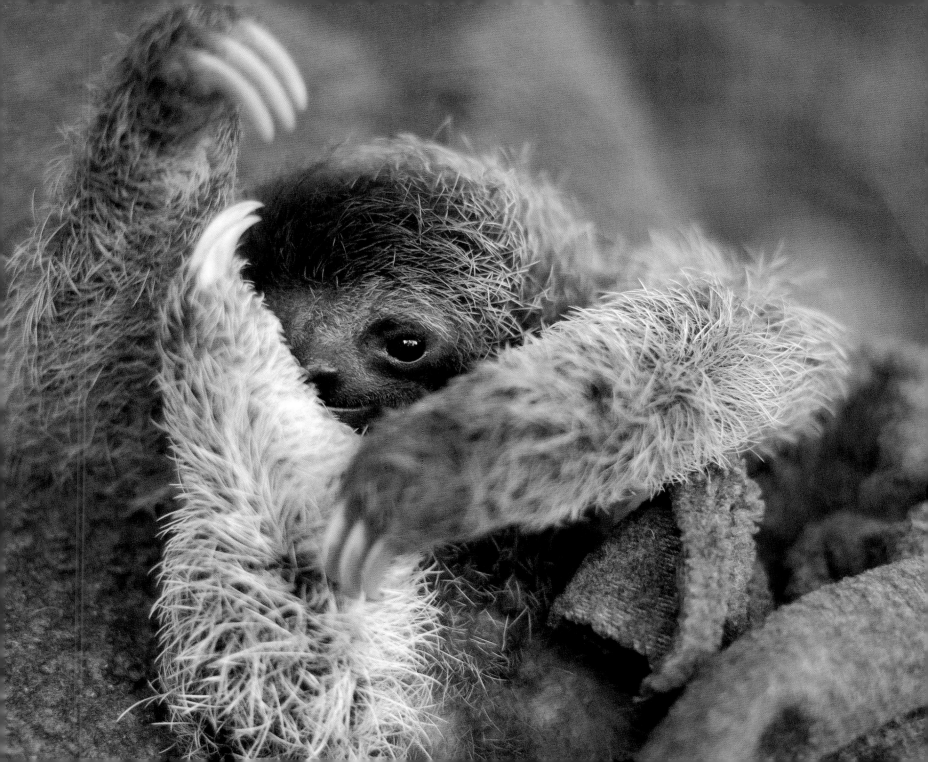

55. Like other mammals, young sloths that are orphaned from their mothers tend to suck on their "thumbs" to comfort themselves. With proper environmental stimulation they grow out of this habit as they get older.

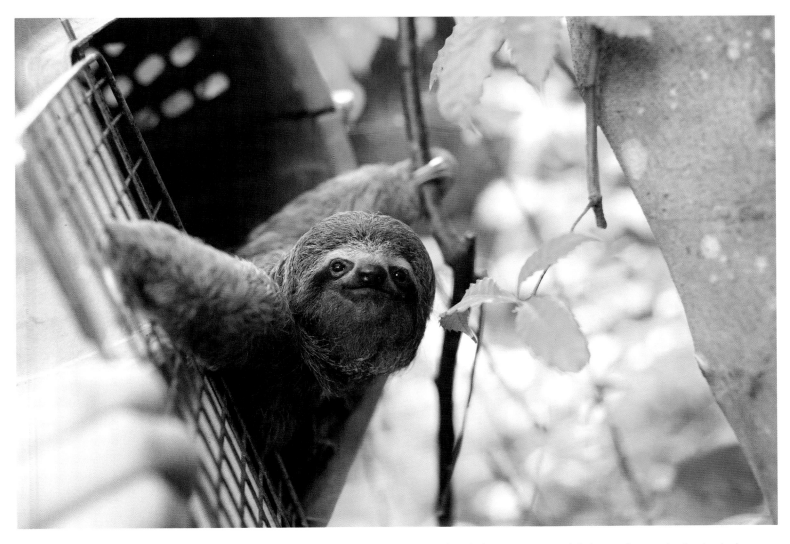

56. Although very cute, sloths make terrible pets. The *only* way to obtain a baby sloth as a pet is to kill the mother and take the baby directly out of the wild. Most of these babies do not survive the voyage to the United States and are dead before they reach the pet store. Sloths are happiest living free in the trees. Please do not support the wildlife pet trade for sloths. You are risking not only the life of that individual sloth but also many others, as well as hurting conservation efforts in the countries where they originate.

Newbie

Someone once asked me, "Which animal was it?" I knew right away what she meant. Which animal was the one who solidified my desire to dedicate my life to sloths? Without hesitation, I said, "Newbie."

While Monster seems like the more obvious answer—and she is everything to me—Newbie is where it all started.

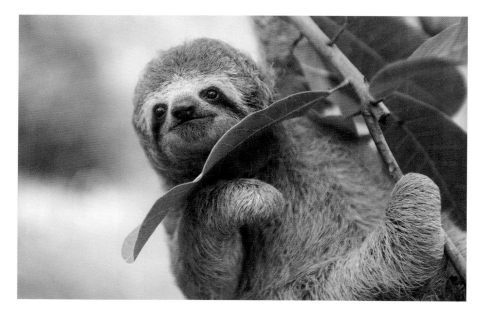

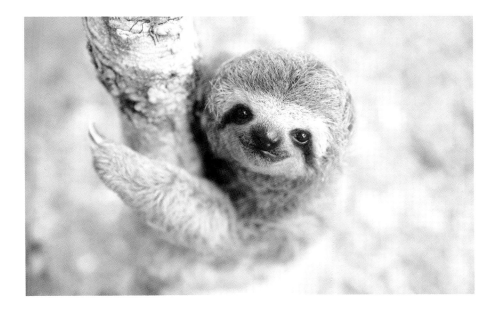

I am no stranger to death. As I approach the eighth anniversary of my father's death, I can't help but be a little extra emotional. I cry over things I'd normally shrug off, and snippets from the past flash through my mind on a more regular basis.

I was there the day my father took his last breaths surrounded by family and friends. I saw the look in his eyes and the way his breathing changed. It all happened right in front of me. As difficult as it was to see my lifelong hero lying in a bed slowly losing his light, I am so glad I was there for his final moments.

So what does all of this have to do with wildlife rescue? Animals die. Often. I know that photos of happy babies cuddled up with a stuffed animal or updates on how Monster is navigating the nursery give the appearance that everything is awesome every day. But what hides behind those fuzzy faces is the fact that wildlife rescue is hard. When animals arrive at the KSTR wildlife clinic, they are all essentially dying—some more quickly

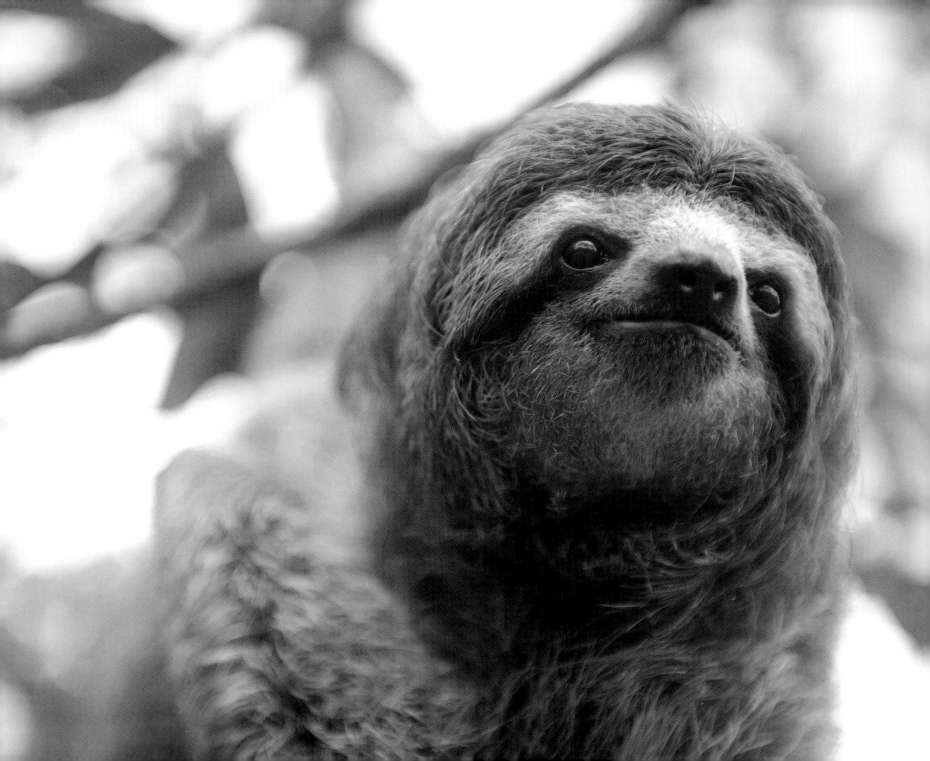

than others. That means our job is to reverse the path to death and heal them so they can make it back to where they belong—in the jungle. The only reason a person is ever able to physically pick up a wild animal is because it is injured, orphaned, or in shock and can't run away and save itself. Wild animals aren't easy to capture. If they are, something is seriously wrong.

I want to talk about Newbie. Those of you who have seen the BBC show *Nature's Miracle Orphans* already know Newbie. She was a three-fingered sloth who arrived at KSTR in October 2013. Her mother had been killed by a dog, leaving Newbie an orphan at only four months old.

The day Newbie arrived, I was just returning from a trip to the United States. I was in San José waiting for my shuttle to Manuel Antonio when I received a message from one of the KSTR volunteers: we had just received a baby three-fingered sloth. I was overcome with the urge to get back and help her, and my shuttle couldn't arrive fast enough. As soon as I made it home, I threw my bags on the floor and ran over to where Newbie was waiting.

That face. Three-fingered sloths just have these faces. They are so expressive, and I swear their eyes stare straight into your soul. Newbie was no exception.

Before long, my world revolved around what Newbie needed—from picking the perfect guarumo leaf, to positioning her cuddle pillow in the exact spot that provided the afternoon sun she so adored, to making sure she had enough time every day in the sunshine and the breeze. Newbie was the queen of the nursery—and of my heart.

I started to daydream about the moment she would be released. How proud I would be of her, how fulfilled I would be knowing she had a chance for a long and happy life. Maybe one day she would even have her own babies. But all those dreams came crashing to a halt the moment she was diagnosed with pneumonia. Pneumonia! Really? Losing her mom to a dog wasn't bad enough?

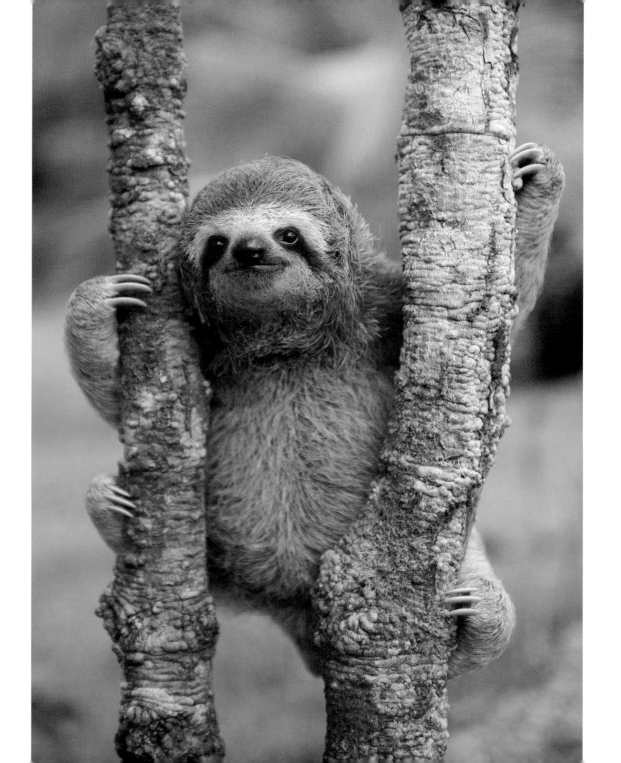

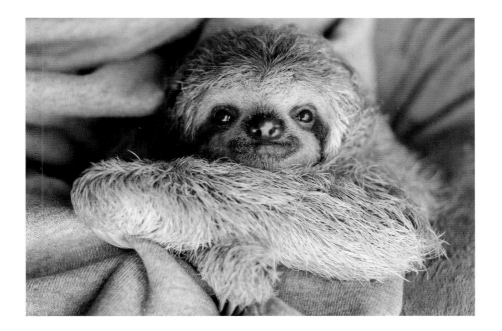

That's when the treatments began. Twice a day for months we made her inhale oxygen laced with medication, and I gave her injection after injection. It physically pained me to stick a needle in her arm. She hated it and would resist every time. She had good days and bad days, and there were a few times when we even thought she was cured. In fact, during filming for the BBC show, we believed she was healthy. After four months of battling nonstop to keep Newbie alive, we finally thought she was out of the woods and her pneumonia was gone. Although deep down I was still worried, I tried to stay positive. We had done everything we could, and it appeared to have worked.

We took Newbie off medications, and a week later I left KSTR for two days of rest and relaxation. I hadn't been gone for more than forty-eight hours, but on the day I returned, Newbie stopped eating. The moment I looked at her, I knew this was it. I put her on oxygen, started her back on

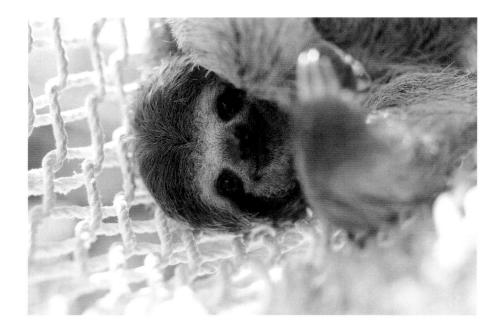

medications, and frantically asked our vet for advice. There must be something else we could do!

At four in the morning I woke up and found Newbie on the floor. She was alive but was so weak she couldn't hold on to anything. I rushed her to the clinic, pressed an oxygen mask to her face like I had done so many times before, and I prayed. I begged and pleaded to anyone who might be listening. I was hoping for a miracle, hoping that somehow the oxygen would revive her. But she just kept deteriorating. Then I saw it. It was the same look my father had in his eyes, the same way he'd gasped for air. Newbie was dying, and there was nothing I could do to stop it. I must have held her for at least three hours after her heart stopped beating.

Wildlife rescue is hard. But we have to keep fighting and push through the sadness to learn from the deaths and, most importantly, bask in the glory of the releases.

Acknowledgments

Kwame Johnson, who believed in this book more than I did sometimes and made the funding campaign a success.

Seda Sejud, my sloth soul sister.

All the volunteers and staff of Kids Saving the Rainforest (www.kstr.org), but especially Barb Braman, Chip Braman, Pia Martin, and Jennifer Rice.

The Sloth Institute Costa Rica (www.theslothinstitutecostarica.org) volunteers: Laura Brietzke, Tom Lawrence, Pedro Felipe Montero Castro, Jill Wallace, and Hannah Youngwirth.

All of the other sloth rehabilitators in the world who work tirelessly every day to save orphaned and injured sloths, but especially those who have helped and inspired me along the way: Leslie Howle (www.toucanrescueranch.org), Monique Poole (www.greenfundsuriname.org/en), Vera Lucia de Oliveira (www.ceplac.gov.br/paginas/Preguica/Inicial.asp), and Tinka Plese (www.aiunau.org).

About the Author

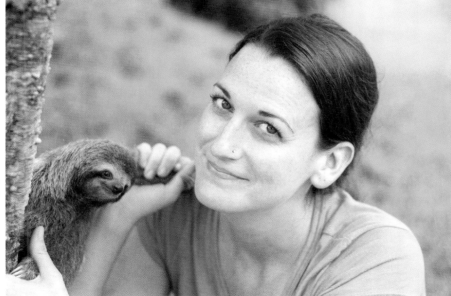

After receiving her BS in zoology from North Carolina State University, Sam Trull went on to earn an MS in primate conservation from Oxford Brookes University in the UK. She has worked with primates and other animal species for almost twenty years. Over the last three years, she has logged over fifteen thousand hours working with sloths and

has become dedicated to their survival and conservation. In August 2014, Sam cofounded the Sloth Institute Costa Rica, whose vision is to enhance the welfare and conservation of sloths through scientific research and education.

In addition to her conservation work, Sam has worked as a photographer since 2010. Her photos have been published by BBC One, BBC Earth, the *Washington Post*, *Good Morning America*, the *Huffington Post*, the *Tico Times*, *La Nación*, the *Independent Weekly*, *Our State* magazine, and others. Sam and the sloths were featured as a main story line in an episode of the BBC One series *Nature's Miracle Orphans*, which aired on PBS stations around the United States.

References

Billet, Guillaume, Lionel Hautier, Robert J. Asher, Cathrin Schwarz, Nick Crumpton, Thomas Martin, and Irina Ruf. 2012. "High Morphological Variation of Vestibular System Accompanies Slow and Infrequent Locomotion in Three-Toed Sloths." *Proceedings of the Royal Society* 279 (1744): 3932–3939.

Britton, S. W., and W. E. Atkinson. 1938. "Poikilothermism in the Sloth." *Journal of Mammalogy* 19 (1): 94–99.

Buchholtz, Emily A., and Courtney C. Stepien. 2009. "Anatomical Transformation in Mammals: Developmental Origin of Aberrant Cervical Anatomy in Tree Sloths." *Evolution & Development* 11 (1): 69–79.

Gaudin, Timothy J. 2004. "Phylogenetic Relationships among Sloths (Mammalia, Xenarthra, Tardigrada): The Craniodental Evidence." *Zoological Journal of the Linnean Society* 140 (2): 255–305.

Gilmore, D. P., C. P. Da Costa, and D. P. F. Duarte. 2001. "Sloth Biology: An Update on Their Physiological Ecology, Behavior and Role as Vectors of Arthropods and Arboviruses." *Brazilian Journal of Medical and Biological Research* 34 (1): 9–25.

Lara-Ruiz, Paula, and Adriano Garcia Chiarello. 2005. "Life-History Traits and Sexual Dimorphism of the Atlantic Forest Maned Sloth *Bradypus torquatus* (Xenarthra: Bradypodidae)." *Journal of Zoology* 267 (1): 63–73.

Mendel, Frank C., David Piggins, and Dale R. Fish. 1985. "Vision of Two-Toed Sloths (Choloepus)." *Journal of Mammalogy* 66 (1): 197–200.

Montgomery, Gene G. 1985. *The Evolution and Ecology of Armadillos, Sloths, and Vermilinguas*. Washington, DC: Smithsonian Institution.

Pauli, Jonathan N., Jorge E. Mendoza, Shawn A. Steffan, Cayelan C. Carey, Paul J. Weimer, and M. Zachariah Peery. 2014. "A Syndrome of Mutualism Reinforces the Lifestyle of a Sloth." *Proceedings of the Royal Society* 281 (1778). doi:10.1098/rspb.2013.3006.

Taube, Erica, Joël Keravec, Jean-Christophe Vié, and Jean-Marc Duplantier. 2001. "Reproductive Biology and Postnatal Development in Sloths, *Bradypus* and *Choloepus*: Review with Original Data from the Field (French Guiana) and from Captivity." *Mammal Review* 31 (3–4): 173–188.

Vizcaíno, Sergio F. 2009. "The Teeth of the 'Toothless': Novelties and Key Innovations in the Evolution of Xenarthrans (Mammalia, Xenarthra)." *Paleobiology* 35 (3): 343–366.

Voirin, Bryson, Madeleine F. Scriba, Dolores Martinez-Gonzalez, Alexei L. Vyssotski, Martin Wikelski, and Niels C. Rattenborg. 2014. "Ecology and Neurophysiology of Sleep in Two Wild Sloth Species." *Sleep* 37 (4): 753–761.

List of Patrons

Slothlove was made possible in part by those people who preordered the book on Inkshares.com. Thank you.

Alyssa L. W. Loney

Anne, Campbell, and Elena Hudson

Brandy Emge Sledge

Chanua Johnson

Christian Lindqvist

Christin Kleinstreuer

Cindy S. Stoll

Courtney Donn

David S. Ferriero

Diana Hicks

Dominique and Nathan Meraz

Emily D. Galik

Evelyn Gallardo

Gail Stockwell

Gail Zimmermann

Geoffrey Bernstein

Iura

Janine Licare

Jen Gaynor

Jennifer Rice

Joanne L. Manaster

John M. Wolfteich

Kayla Kolberg

Kerstin A. Johnson

Krista Maija Zvanitajs

Liz Warren

Mandy Matson

Mariana Balanzario Gutiérrez

Martha K. Countess

Molly Kainuma

Nadine Folger

Phyllis A. Clark

Rhonda Wolfteich

Richard and Megan Charboneau

Sally and Jess

Sarah Brietzke

T. R. Lawrence

Virginia Ann Rady

Wendy Gerard

Inkshares

Inkshares is a crowdfunded book publisher. We democratize publishing by letting readers select the books we publish—we edit, design, print, distribute, and market any book that meets a preorder threshold.

Interested in making a book idea come to life? Visit inkshares.com to find new projects or start your own.